THE
Campfire
Foodie
COOKBOOK

Simple Camping Recipes with Gourmet Appeal

Recipes and Photography by Julia Rutland

Adventure Publications
Cambridge, Minnesota

DEDICATION

To my favorite camping companions, Dit, Emily, and Corinne: Thank you for making outdoor adventure so cozy and fun. To Greg, Matthew, and Sam: I appreciate that you're always willing to try a new outdoor skill—safe or otherwise. And to all the friends with whom I have shared a campfire and meals: May your firewood stay dry and your coolers stay filled.

Thanks to Brett, Emily, and Tim for guiding the book. May all your outdoor meals taste like feasts. And thanks to Mark Kelly at Lodge Cast Iron for the gear and well-seasoned advice.

Finally, a special thanks to all the unknown folks taking care of private and public campgrounds along with the helpful crew at The National Park Service, Bureau of Land Management, National Forest Service, National Wildlife Refuge, and countless state and county park systems.

Cover and book design by Jonathan Norberg

Photo credits: All photography and recipe styling by Julia Rutland

10 9 8 7 6

The Campfire Foodie Cookbook
Copyright © 2017 by Julia Rutland
Published by Adventure Publications
An imprint of AdventureKEEN
310 Garfield Street South
Cambridge, Minnesota 55008
(800) 678-7006
www.adventurepublications.net
All rights reserved
Printed in China
ISBN 978-1-59193-556-8 (pbk.); 978-1-59193-671-8 (ebook)

TABLE OF CONTENTS

INTRODUCTION

SHARING A KITCHEN WITH MOTHER NATURE

There's something about a campsite that makes everything taste better. I'm not sure if it's the scent of the trees or the campfires—or, perhaps, that nature itself casts a seasoning over your meals, making them richer and more satisfying. Either way, eating by a campfire brings a special kind of satisfaction. Let the evening cicadas and tree frogs serenade you with soothing sounds that you just can't get indoors. Note: A good portion of these recipes give instructions for prepping much of the ingredients at home before you leave. So whether you love to plan ahead or take a more leisurely approach, we've got you covered.

COOKING EQUIPMENT TO BRING WITH YOU

It should come as no surprise that the equipment you'll need for your campfire depends on the type of camping you're doing. For backpackers, you'll want the equipment to be minimal, as your back will thank you. For this reason, we've called out the weight per serving for each recipe. Car and RV campers, in contrast, have access to a far wider variety of cooking gear; high-end RV kitchens are essentially slightly cramped versions of the real thing.

For Backpackers

- Hang bags and cord or bear canisters
- Water treatment
- Lightweight cookstove, fuel, cookware set to include a small saucepan and nonstick skillet
- Bear spray
- Matches/lighter
- Lightweight plastic bowl (can serve double-duty as a plate)
- Cup: for both hot and cold beverages (can also serve as a bowl)
- Spork or multipurpose cutlery
- Can/bottle opener

For Car and RV Campers

Tent camping from your car or RV camping feels downright luxurious when you are used to carrying kitchen gear and bedding on your back! There's more flexibility with cooking styles because cast-iron and portable gas grills become an option. The gear lists are essentially the same, except that you may include baking dishes with motor home camping because some models are equipped with small ovens.

- Camping stove and/or barbecue grill
- Grill rack
- Charcoal or liquid fuel
- Lighter/matches (store in plastic bags to keep dry)
- Long metal tongs (short ones are tricky to use when reaching into a fire!)
- Nonstick skillet (cast iron for car and RV campers; everyone else can use a lightweight aluminum one) Note: If using a coated pan, use only wood, plastic, or silicone-coated utensils to avoid scratching the surface; replace the entire pan as needed.
- Meat thermometer
- Knives and cutting board
- Mixing bowl
- Measuring cups
- Colander
- Pastry brush
- Vegetable peeler
- Silicone spatula
- Metal spatula
- Aluminum foil
- Dishwashing tub with sponge
- Oven mitts or pot holders
- Whisk
- Ladle

For RV Campers

Motor homes are outfitted with many of the same appliances that you have in your kitchen right now—just smaller. What IS different is how the refrigerator runs. Follow the instruction manual and remember these tips: Keep the RV level, plan for a 4- to 6-hour cool-down before adding food, load fridge with cold food, and limit the number of times you open the door.

In addition to the equipment that car and RV campers bring along, don't forget baking/casserole dishes and sheet pans (also known as baking sheets). When packing, keep in mind that an RV oven is probably smaller than the one you have at home.

PACKING YOUR COOLER

Most of the recipes in this book give instructions for preparing some (or all) of the ingredients at home, so a well-packed cooler is essential to a good campfire experience. And chilling your

perishable food does more than just keep veggies crisp and beverages cold. It's absolutely critical for food safety. Here are some tips for easy and healthy packing.

- Freeze bottles and sealable containers of water. Bagged ice is great for getting into crevices, but the larger blocks melt slower and last longer. Use clean, potable water so it's drinkable when melted.

- Wash fruit and veggies before packing. Cut bulky and awkward pineapple and most melons so they take up less space.

- Marinate meat according to the recipe, then freeze. It'll serve as a freezer block, and you won't have to cook the meat dishes as you set up camp.

- Pack fragile, easily bruised fruits and veggies on top. Pack meats on the bottom because they are sturdier; if any leakages occur, the meat juices will not contaminate other foods.

- Double bag containers with a lot of liquid. If using plastic storage containers, wrap in sealable plastic wrap or place the tub in a large plastic bag. The double wrapping will save you from disasters, and you can repurpose bags for separating damp towels and clothes.

- Consider keeping a separate cooler for beverages. Constantly opening and closing the lid to retrieve drinks will cause the ice to melt faster.

- Start off cool. If ice will not be available on the trip, make the most of what you bring by chilling the cooler with ice before packing food. At the very least, bring your cooler inside the day before so it's not starting off hot from the attic.

- Chill all foods before placing in the cooler. Warm beverages will cause the ice to melt faster (and you'll have to wait longer for that celebratory cold beer after setting up camp).

- Layer ice and food, starting with ice at the bottom of the cooler. If you end up with extra space at the top of the cooler, top with bubble wrap for extra insulation.

- Keep the cooler in the shade. If that's not possible, cover it with a light-colored towel.

A Few Other Packing Tips

Pack the night before, including all your gear. Yes, you are tired from the long workweek, but make yourself do it. Packing on a groggy morning is a sure way to forget something important. Set up your coffee maker with to-go mugs ready. Your vacation will start off in a happier place.

If space provides, pack nonperishables in boxes and cartons destined for the recycling bin. They'll help prevent breads, cookies, and other fragile food from getting crushed. For super organization, pack each meal's dry ingredients in a box.

Put paper plates or paper towels in between nonstick pans to keep the slick finish from getting scratched during storage.

Larger ice melts more slowly, so it will keep food in your cooler chilled longer. Freeze water jugs, if space allows. Or fill zip-top plastic storage bags with water, and lay them flat in the freezer. Once frozen, use them to line the bottom and sides of the cooler. When melted, use the water for coffee or soups.

CAMPFIRE COOKING

Cooking over an open wood fire is the ultimate experience.

- If possible, use an established fire pit. If creating your own, look for a large flat rock or layer of sand as a base, making sure roots and leaves are well out of the way to prevent errant fires. Avoid overhanging branches. Pile rocks around the outside as a windbreak and to contain flames and sparks. Also, when you're cooking in bear country, practice safe camping practices and keep this bear safety advice in mind: www.fs.fed.us/visit/know-before-you-go/bears.

- Have firewood and lots of tinder (dry leaves, grass, wood shavings) and kindling (small twigs and branches) in piles ready to use. If gathering, look for dry wood that snaps easily. Try to use logs no larger than your wrist or forearm because large logs take a while to get started.

- Keep a bucket of water, a fire extinguisher, or a shovel for sand and dirt to put out the fire. After you're done, scatter ashes and embers and sprinkle with water, stirring occasionally, until smoldering stops.

Building the Campfire

- Teepee style: Arrange kindling in a cone shape around a small pile of tinder. Once lit, add logs a few at a time.

- Log Cabin style: Place two equal-size logs side by side with a few inches in between. Add two logs on top, perpendicular to the first two, to form a square. Repeat for a few more layers, using the largest logs on the bottom. Leave space between logs so fire can get oxygen. Place tinder in center and top with kindling and more tinder.

- Pyramid style: Place four of the largest logs side by side. Place another layer on top, perpendicular to the first logs. Continue to alternate logs, using the smallest on top to form a pyramid shape. Place kindling and tinder on top.

Of course, you may prefer to bring along a small charcoal grill when you're camping. For charcoal grills, arrange coals on one side of the grill or light coals throughout the bottom and carefully move the charcoal with tongs to one side. To avoid flare-ups, place a metal drip pan on the unheated side to catch fat and liquids.

- High heat (450° to 600°)
- Medium-high heat (400° to 450°)
- Medium heat (350° to 400°)
- Medium-low heat (275° to 350°)
- Low heat (225° to 275°)

The Fuel: Lump charcoal lights quickly, burns hot and long, and gives food a light smoky flavor without additives.

Briquettes made from sawdust wood chips are popular for ease of use and consistent size. Some versions are infused with lighter fluid. The additives can give off a chemical smell that is lessened if covered in white ash before food is added.

Chimney Starter: Use a chimney starter with charcoal not treated with lighter fluid. Fill the chimney with an adequate number of briquettes or charcoal, and place it on the lower grill grate. Wad up a few sheets of newspaper and place them under the chimney. Light the newspaper, and allow the flames to light the charcoal. Drizzle a little bit of cooking oil on the charcoal to enhance lighting. After 10 minutes, flames should appear at the top and coals should be coated or edged in white ash. Dump coals onto the lower grate. Wait about 5 minutes or until charcoal is pale gray and flames subside; then spread coals into an even layer. Make sure the upper grate preheats before adding food.

Lighter Fluid: Arrange coals into a mound in the center of the bottom grill grate. Add lighter fluid per directions. Immediately light coals and allow to flame. NEVER squirt lighter fluid onto flaming coals. When briquettes are covered in white ash, spread to an even level.

Replenishing Charcoal: For Dutch-oven baking or grilling thick foods with lengthy grilling times, you may need to replenish the fuel. Start this process before the coals get cold. You won't need to add lighter fluid or starter, as the lit coals should ignite the new ones. You can also start new coals in a chimney in a safe location, and then add them to the fire with long tongs.

Greasing Grill Grates: Pour a tablespoon of cooking oil into a small bowl. Fold a paper towel into a square and hold it with long tongs. Dip the towel in the oil; brush it over the grill grate.

COOKING WITH GAS GRILLS

Gas Grills: Propane or butane-fueled grills offer easy, consistent grilling. They are ideal when grilling small quantities of quick-cooking foods. To achieve the smoky flavor that charcoal fires offer, use smoking chips. Soak aromatic wood chips in water at least 30 minutes, and then place them in heavy-duty aluminum foil. Wrap foil to seal, and pierce many times with a stick or fork to allow smoke to escape into the grill. Use a lid so smoke comes into contact with food.

Use the Lid: Lids and covers for grills are optional, but they help control the heat so the food cooks evenly and quickly, especially in cold, windy, or wet weather. A lid also helps the aromatic smoke to penetrate the food. Small portable grills don't often have lids; use an upside-down Dutch oven, large cast-iron skillet, or large piece of aluminum foil to improvise, if necessary.

Cookstoves: One of the most useful pieces of cooking equipment for camping is a portable stove. Many camping areas have bans on fires in the dry summer months, so owning a camp stove means you'll always be able to have a hot meal. They come in a variety of sizes with various types of fuel. Use the one most suited for your camping and cooking style, keeping in mind that a couple might grow into a large family that needs more than a single burner. A windbreak is essential, so purchase one if it's not built into the stove unit. For ease, use a camp table to elevate your cooking surface to a comfortable height.

Level ground is valuable at a campsite. It's more important to site your cooking area on level ground than to set up your sleeping tent there. (You can always situate your sleeping bag so that your head is uphill!) Cooking on uneven surfaces is dangerous and annoying, as pans can slide right off the cookstove and onto the ground. At the very least, cooking oils and sauces will drift to the lower side, leaving the shallow side to burn foods.

DIRECT GRILLING VS. INDIRECT GRILLING

Direct grilling is like broiling, only the intense heat is under the food, not above it. Raising and lowering the grill grate and opening/closing air vents affect the level of heat in a charcoal grill. For gas grills, a simple turn of the knob changes the heat level. Use direct heat to cook steaks, kebabs, chicken breasts, sausages, and vegetables.

Indirect grilling is similar to baking or oven roasting. Use indirect heat for thick foods like bone-in chicken quarters or thick steaks—anything that requires 25 minutes or more of cook time. A closed grill lid enhances the oven effect and keeps

the temperature steady. It's easy to do with gas grills: Light the entire grill, and then turn off one side. Many times food is quickly seared on the hot side, then moved over to the cooler, indirect side to continue to cook without burning the exterior.

COOKING IN AN RV KITCHEN

Motor homes often contain full kitchens that include a refrigerator, sink, cooktop, microwave, or a microwave-oven combo. The refrigerators keep food cold once they "chill down" but lose their cool quickly when the doors are opened. Decide what you are going to grab before you open the door, and remember that contents shift around, so be sure to keep glass items secure.

RV stoves work similarly to traditional gas cooktops, with one exception: You need to replenish the liquid propane fuel. Some RVs benefit from small ovens, so there's really no limit to what can be prepared in a motor home kitchen. Be ready to downsize your sheet pans and baking dishes to fit the smaller dimensions of the equipment in these mobile kitchens.

Tip: Remember that food aromas—good and bad—will waft around the sleeping quarters, unless you have time to open some windows and doors before bedtime.

DUTCH-OVEN COOKING OVER A FIRE OR CHARCOAL

Cast-iron Dutch ovens are ideal for cooking over fire or charcoal. The thick, heavy material heats more evenly than thin aluminum and helps avoid scorched or uncooked food. A camp-style Dutch oven will have small legs on the bottom to elevate it above hot coals and a flat lid so coals can be placed on top, creating an oven effect.

- **Cast-Iron Dutch Oven:** 10- or 12-quart-size ovens will cook a wide range of recipes. If your oven is a bit large for the recipe, the ingredients will be in a thinner layer and will probably cook faster. Be more careful when squeezing ingredients in a too-small oven because they may boil over and take a bit longer to cook.

- **Charcoal:** Although solid wood charcoal is more natural, for consistency's sake, these recipes call for standard-size commercial briquettes. Avoid briquettes that have been pre-soaked with starter fluid, as they can add a chemical flavor to foods.

- **Chimney Starter:** These must-have containers help start charcoal quickly and evenly. The chimney starter is a metal cylinder with a wire grate at the bottom that holds charcoal. Newspaper is wadded up, placed on the bottom, and then lit. The fire lights the charcoal above. Although they have handles, wear an oven mitt or heavy gloves to protect your hands from the intense heat. Always use the chimney on a flameproof surface such as concrete or dirt, never on dry grass or a wooden deck.

- **Coal Tray:** A metal tray, such as a thick, rimmed commercial sheet pan found at restaurant-supply stores, is a fail-safe surface on damp or uneven ground. When the weather is windy, set up a metal screen or improvise one out of aluminum foil.

- **Tongs:** Long metal tongs are necessary to move and replenish hot, lit coals.

- **Lid Lifter:** This is an optional tool, but its design makes it easier to lift the heavy, coal-topped lid from the Dutch oven with less likelihood of spilling lit coals and ash in the food.

- **Oven Mitts:** Thick, insulated gloves protect hands and forearms from heat. Welder's gloves are often utilized, but make sure they are loose enough to sling off quickly if the leather gets too hot.

- **Whisk Broom:** Use a short-handled, natural-fiber (plastic will melt!) broom to whisk away ash from the top of the lid when cooking is finished. This helps prevent ash from floating up and settling in your food.

Dutch-Oven Tips

- Shallow Dutch ovens are good for baking cakes and breads, while deep ones are suited for soups and stews.

- Try not to peek—lots of heat will escape when you lift the lid. Use a specially designed lid lifter and appropriate oven mitts. Take care not to tilt the lid, as ash and coals can slip into the food.

- Space coals evenly under and on the oven, about 1 inch apart in a circular pattern. Don't cluster coals in the center UNDER the oven, as they will create a hot spot that will scorch the food. Continue to place coals about 1 inch apart along the rim of the lid, but place about 2 coals on either side of the center handle.

- Hot spots in a charcoal fire are inevitable, especially as some pieces burn out. Rotate cast-iron pots and pans about a quarter turn every 15 minutes.

- You know to use wood or silicone utensils for nonstick pans, but they are also recommended to maintain the seasoning in cast-iron pieces.

- In cold, windy weather, you may need a few more pieces of charcoal to maintain the temperature. Add a few new briquettes to top and bottom, making sure they light and heat up before the others burn out.

- For soups, stews, and fried foods: Keep all coals on the bottom with about the same amount of briquettes as the diameter of the oven. For example, if frying in a 10-inch oven, use about 10 briquettes under the oven.

Feel the Heat

There are several ways to calculate how many coals you'll need to "bake" in your Dutch oven, and a rough estimate is twice as many coals on top than on the bottom. Remember to set aside extra briquettes for any food that takes longer than 40 minutes to cook. Place unlit charcoal briquettes against lit pieces every 20 minutes to keep the heat consistent.

- **Plus 4, Minus 4:** To determine how many coals to place on the Dutch-oven lid, add 4 to the diameter of the Dutch oven. Subtract 4 to get the number for the bottom. That means on a 12-inch oven, you would put 16 on the lid and 8 under the oven.

- **Double Wide:** Another method is to take the width of the Dutch oven and double it. Put ⅓ briquettes under the oven and ⅔ on the lid. For a 12-inch Dutch oven, you would use 24 briquettes, putting 16 on top and 8 on the bottom.

Sometimes you need a specific temperature. The Lodge Manufacturing Company did the hard work and created this handy chart for baking at temperatures from 325° to 450°.

Number of Briquettes—on Top/Bottom (Total)

Temperature	8" Oven	10" Oven	12" Oven	14" Oven
325° F	$\frac{10}{5}$ (15)	$\frac{13}{6}$ (19)	$\frac{16}{7}$ (23)	$\frac{20}{10}$ (30)
350° F	$\frac{11}{5}$ (16)	$\frac{14}{7}$ (21)	$\frac{17}{8}$ (25)	$\frac{21}{11}$ (32)
375° F	$\frac{11}{6}$ (17)	$\frac{16}{7}$ (23)	$\frac{18}{9}$ (27)	$\frac{22}{12}$ (34)
400° F	$\frac{12}{6}$ (18)	$\frac{17}{8}$ (25)	$\frac{19}{10}$ (29)	$\frac{24}{12}$ (36)
425° F	$\frac{13}{6}$ (19)	$\frac{18}{9}$ (27)	$\frac{21}{10}$ (31)	$\frac{25}{13}$ (38)
450° F	$\frac{14}{6}$ (20)	$\frac{19}{10}$ (29)	$\frac{22}{11}$ (33)	$\frac{26}{14}$ (40)

FOOD SAFETY

To avoid food-borne illnesses, keep potentially hazardous food at the proper temperature. These foods include meat, poultry, eggs, seafood, dairy products, cut fruit and vegetables, raw sprouts, garlic-oil mixtures, cooked potatoes, cooked beans, and cooked rice. Specifically, hot food should be served at or above 140° and cold food at or below 40°. The range in between is known as the "danger zone," a range in which bacteria multiplies rapidly.

Meat, poultry, and certain seafood need to reach a safe minimum temperature—there's no worse place to endure a bout of food poisoning than in the wilderness! Below are final cooking temperatures from foodsafety.org.

Food	Minimum Temperature
Ground Beef	160°
Ground Poultry	165°
Beef or Lamb Steaks	145° (with at least a 3-minute rest after cooking)
Chicken, Turkey, Duck	165°
Precooked Ham	140°
Pork	145° (with at least a 3-minute rest after cooking)
Egg Dishes	160°
Leftovers and Casseroles	165°
Fish*	145° (until fish is opaque and flakes easily with a fork)
Shrimp and Scallops	until opaque and firm
Clams, Oysters, Mussels	until shells open during cooking

* If you prefer your salmon and tuna to be seared or cooked rare, buy previously frozen fish from a reputable market. Always cook fresh-caught fish until well done.

MAKE A MARINADE

Once you get the hang of campfire cooking, you'll likely want to spice things up. One way to do that is with a marinade. Infusing food with a marinade not only adds flavor—it tenderizes meats too. Most marinades contain a bit of oil, some spices and flavoring, and an acid like lemon juice or vinegar. Use the following tips for successful marinating.

- Use glass or plastic containers such as food-safe plastic storage bags. Stainless steel is okay, but avoid marinating in aluminum.

- Keep marinated foods cold, either in the refrigerator or surrounded by ice in a cooler.

- Don't reuse a marinade used on meat. If you want to use some of the marinade as a sauce, set some aside or boil it in a saucepan for at least 2 or 3 minutes after draining from meat. If grilled vegetables have been tossed in a seasoned mixture, it's okay to return them to the same bowl.

You can start your marinade before you leave home, but remember that while heavy, dense meats like steak and pork will do fine in a lengthy marinade, light fish and seafood shouldn't soak longer than 30 minutes because the texture will suffer. Use this chart to plan your meals.

Food	Length of Marinade*
Chicken, Turkey, Duck (breasts)	2 hours to overnight, up to 2 days
Chicken (thighs and legs)	1 to 6 hours, up to 2 days
Beef Steaks and Pork Loin, Chops	2 to 4 hours, up to 5 days
Fish and Shrimp	15 to 30 minutes
Scallops	5 minutes
Vegetables	30 minutes to 2 hours

* Very acidic marinades—those containing a lot of lemon or lime juice—can toughen meats, so follow the recipe if preparing this way.

HANDY SUBSTITUTIONS FOR WHEN AN INGREDIENT RUNS LOW

Sometimes when you're camping, you run out of an ingredient. When that happens, all's not lost. Here are some helpful substitutions that may save the day.

1 cube bouillon (or 1 teaspoon bouillon granules) + 1 cup hot water = 1 cup broth

1 cup milk = 3 tablespoons instant powdered milk + 1 cup water

1 cup buttermilk = 1 cup milk + 1 tablespoon lemon juice or vinegar

1 egg = 1 tablespoon powdered eggs or powdered egg replacer + 2 tablespoons water

1 egg = ½ mashed banana or ¼ cup applesauce or ¼ cup mashed potatoes

1 tablespoon butter = ¾ teaspoon butter sprinkles

1 cup ricotta cheese = 1 cup drained cottage cheese

1 teaspoon baking powder = ¼ teaspoon baking soda + ½ teaspoon cream of tartar

3 ounces or 3 (1-ounce) squares semisweet chocolate = ½ cup semisweet morsels

1 ounce unsweetened chocolate = 3 tablespoons cocoa powder + 1 tablespoon butter

1 garlic clove = ⅛ teaspoon garlic powder

1 tablespoon chopped fresh herb = 1 teaspoon dried

1 cup honey = 1 ¼ cups sugar + ¼ cup water

2 cups tomato sauce = 1 cup tomato paste + 1 cup water

½ cup mayonnaise = ½ cup plain Greek yogurt = ½ cup sour cream

DON'T FEED THE CRITTERS

One benefit to camping is enjoying nature, including sharing the experience with the native wildlife. Never feed a wild animal. Let me say that again: Never feed a wild animal. In bear country, cook meals at least 100 yards away from your sleeping area; avoid having leftovers; disperse dish-washing water on rocks, if possible; use bear-resistant containers; and don't wipe your hands on your clothes while prepping dinner or while eating. Mice, raccoons, and large birds are annoying at best, so don't give them any reason to forage in your gear.

Breakfast & Breads

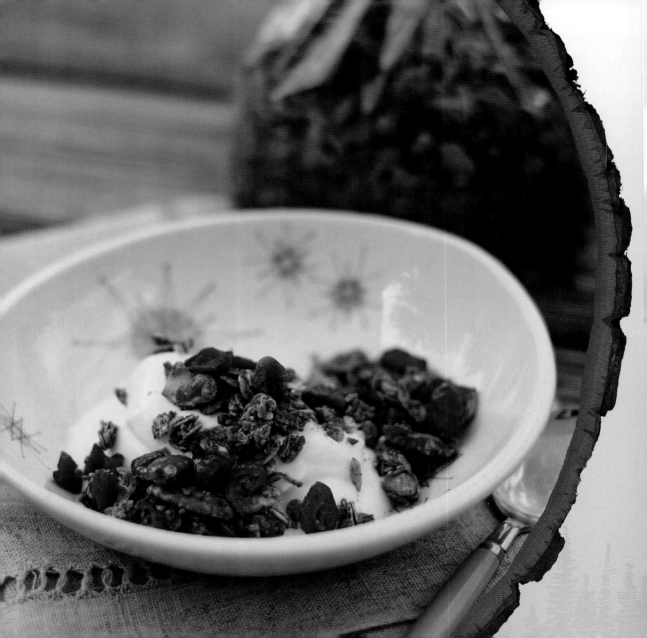

NUT-AND-HONEY GRANOLA

ONCE YOU START making your own granola cereal, it's hard to go back to basic grocery store brands. You can substitute coconut oil for butter, but add a bit of salt to round out the flavor. Add dried fruit just before serving because it can get hard and chewy if baked or stored with the oats mixture.

- 8 cups rolled oats (old-fashioned or quick)
- 4 cups chopped or sliced nuts (pecans, almonds, walnuts)
- 1 cup honey
- ¾ cup light brown sugar
- ½ cup butter or coconut oil and ¼ teaspoon salt
- 1 tablespoon vanilla extract
- 3 to 4 tablespoons ground cinnamon
- Salt
- 1 to 2 cups dried cranberries, cherries, and/or golden raisins

PREP AT HOME:

Preheat oven to 325°.

Combine oats and nuts in a large bowl. Set aside.

Combine honey, brown sugar, butter, vanilla, cinnamon, and salt to taste in a saucepan over medium-low heat. Cook 2 minutes, stirring frequently, or until mixture is smooth and well blended.

Pour butter mixture over oat mixture, tossing to coat. Spread out on 2 or 3 aluminum foil-lined baking sheets. Bake 30 minutes, stirring and rotating pans every 10 minutes until golden brown. Let cool on baking sheets (mixture will crisp when cool). Store in an airtight container.

AT CAMPSITE:

Stir in dried fruit, or combine dried fruit with granola just before serving.

Variation: For a popular trail mix, stir in candy-coated chocolate pieces or chocolate morsels (keep cool or they will melt), mini pretzels, and dried fruit.

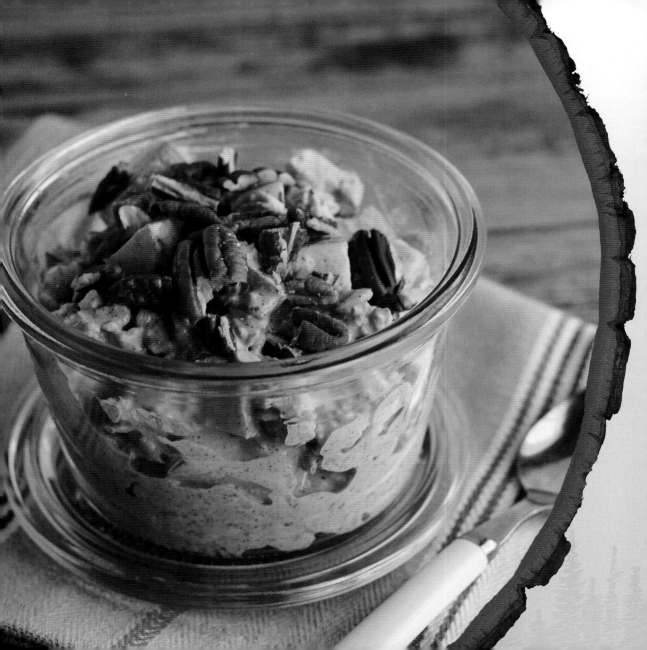

2 teaspoons toasted chopped pecans or walnuts

1 cup old-fashioned oats

1 cup skim (nonfat) milk

1 cored and chopped apple

2 teaspoons brown sugar or honey

½ teaspoon apple pie spice or ground cinnamon

PREP AT HOME:

Toast nuts; store in an airtight container.

Combine oats, milk, apple, brown sugar, and spice; divide equally into 2 (1-cup) jars or bowls.

Cover and refrigerate or place in an ice-filled cooler 8 hours or overnight.

AT CAMPSITE:

Before serving, stir oats, and sprinkle each serving with 1 teaspoon pecans.

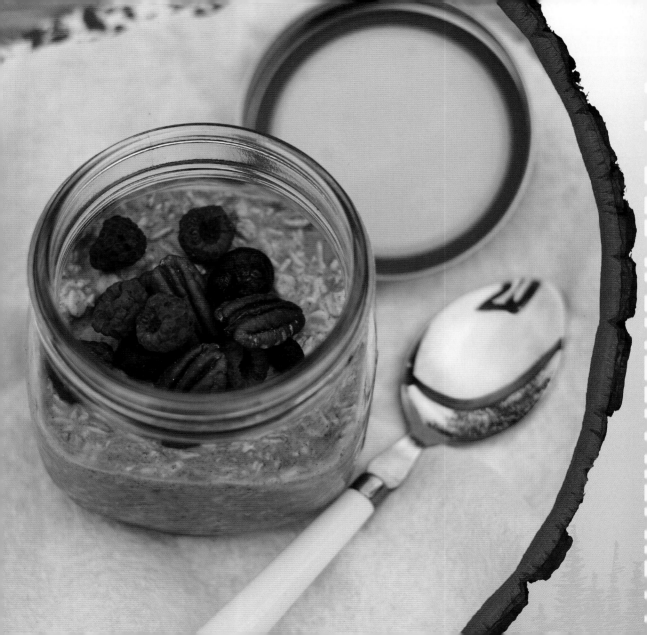

OVERNIGHT CHAI OATMEAL

1 cup old-fashioned oats

¼ teaspoon ground cinnamon

¼ teaspoon ground cardamom

¼ teaspoon ground nutmeg

1 cup almond-coconut milk

2 heaping tablespoons toasted coconut

TOPPINGS: raspberries, blueberries, and pecan halves

PREP AT HOME:

Combine oats, spices, and milk; divide equally into 2 (1-cup) jars or bowls.

Cover and refrigerate or place in an ice-filled cooler 8 hours or overnight.

Toast coconut; store in an airtight container.

AT CAMPSITE:

Before serving, stir oatmeal mixture (oats, spices, milk). Sprinkle with toasted coconut, additional cinnamon, and, if desired, toppings.

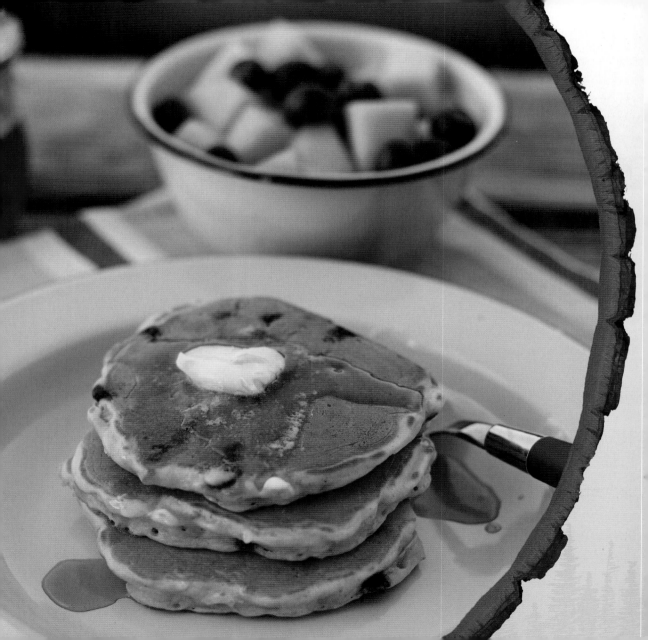

1 ½ cups Basic Baking Mix (page 239)

½ cup old-fashioned or quick oats

¾ cup semisweet chocolate morsels

1 cup whole or lowfat milk

2 large eggs, lightly beaten

Vegetable oil or cooking spray

¼ cup butter

¼ to ½ cup maple syrup

PREP AT HOME:

Prepare Basic Baking Mix. Stir in oats and chocolate. Store in an airtight container.

AT CAMPSITE:

Assemble a camp cookstove or prepare a gas or charcoal grill.

Place oats mixture (Basic Baking Mix, oats, and chocolate) in a large bowl. Combine milk and eggs in another small bowl or measuring cup. Gently stir milk mixture into oats mixture.

Preheat griddle, nonstick skillet, or well-seasoned cast-iron skillet over medium-high heat. To test, sprinkle a couple of droplets of water on pan—they should sizzle and dance across the pan.

Lightly coat pan with vegetable oil or cooking spray. Ladle or spoon about ¼ cup batter for each pancake. Cook until large bubbles form on top and bottom is light golden. Turn and cook 30 seconds. Repeat with remaining batter. Serve with butter and/or maple syrup.

Tip: Make one pancake to test the heat before filling the skillet with several pancakes.

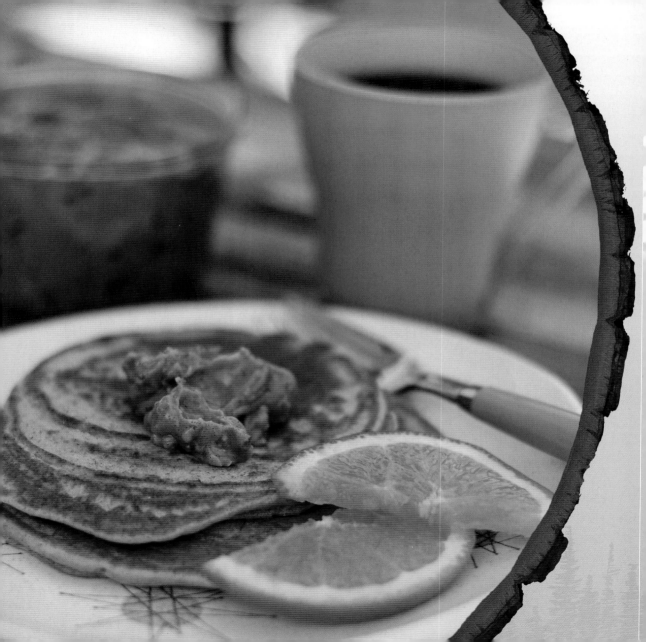

¼ cup Honey-Pecan Butter (page 247)

2 large eggs, lightly beaten

½ teaspoon grated orange zest (optional)

1 cup orange juice

1 ½ cups Whole Wheat or Basic Baking Mix (page 239)

Canola oil or cooking spray

PREP AT HOME:

Prepare Honey-Pecan Butter. Store in refrigerator up to 2 weeks or in the freezer up to 3 months.

Prepare Whole Wheat Baking Mix. Store in an airtight container.

AT CAMPSITE:

Assemble a camp cookstove or prepare a gas or charcoal grill for medium-high heat. Remove Honey-Pecan Butter from cooler to soften.

Combine eggs, zest, and juice in a medium bowl. Stir in baking mix.

Preheat griddle, heavy-bottomed nonstick pan, or well-seasoned cast-iron skillet over medium-high heat. To test, sprinkle a couple of droplets of water on pan—they should sizzle across pan.

Lightly coat pan with canola oil or cooking spray. Ladle or spoon about ¼ cup batter for each pancake. Cook until large bubbles form on top and bottom is light golden. Turn and cook 30 seconds. Repeat with remaining batter. Serve with Honey-Pecan Butter.

Tip: Make one pancake to test the heat before filling the skillet with several pancakes.

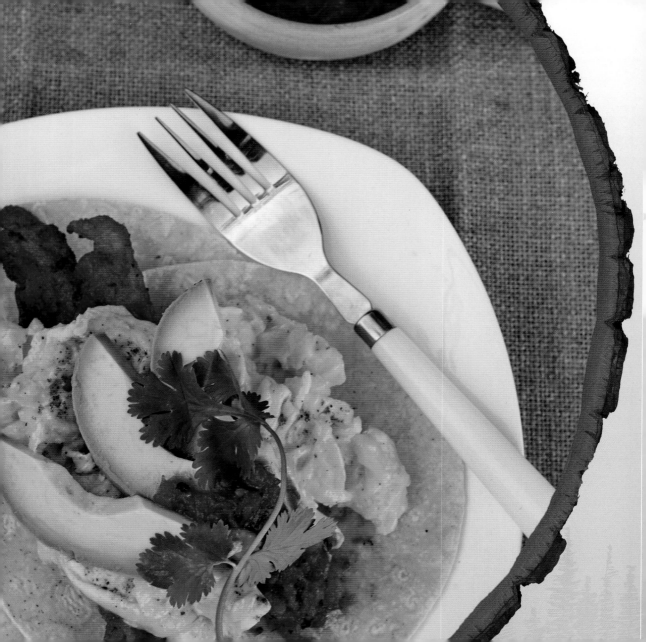

4 to 8 slices bacon

8 corn tortillas

8 large eggs

2 teaspoons Mexican or Taco Seasoning Blend (page 229)

1 avocado, sliced

1 cup Fresh Tomato Salsa (page 55) or Quick Smoky Salsa (page 57)

4 sprigs fresh cilantro, chopped, or 2 teaspoons freeze-dried cilantro

PREP AT HOME:

Prepare Mexican or Taco Seasoning Blend; place in a small plastic storage bag.

If desired, prepare salsa; store in an airtight container in the refrigerator.

AT CAMPSITE:

Prepare a charcoal or gas grill, or assemble a camp cookstove.

Cook bacon in a heavy skillet over medium-high heat until crispy. Transfer to a paper towel. Drain all but 1 tablespoon drippings. Place tortillas over heat 20 to 30 seconds on each side or until warm. Wrap in foil and place near heat to keep warm.

Heat drippings over medium heat. Stir together eggs and seasoning blend in a medium bowl. (If you work quickly, you can crack eggs right into the skillet and stir in the seasoning mix, saving you the cleanup of another bowl.) Add eggs to drippings and cook until set but still moist. Remove from heat.

To assemble, place tortillas on a work surface or serving plate. Top evenly with bacon, eggs, avocado slices, salsa, and cilantro. Roll and eat immediately.

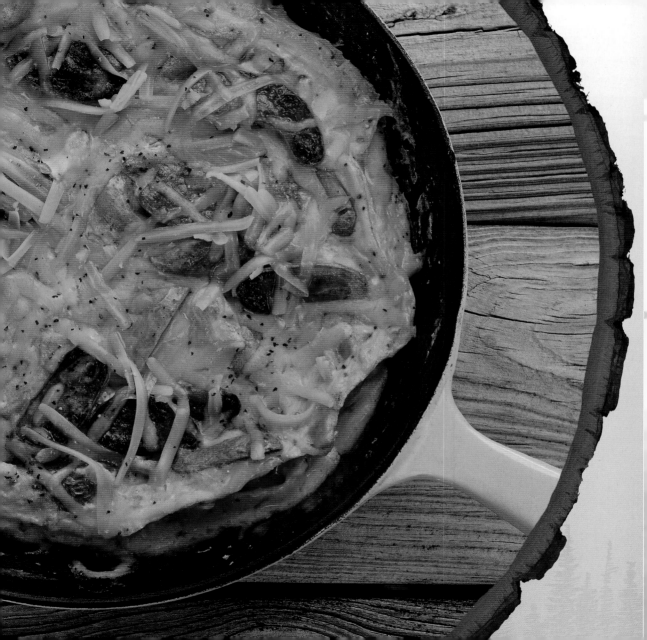

THIS SIMPLE ham-and-egg dish appeals to everyone. Make it a little more interesting by stirring in a chopped leek and 1 teaspoon fresh thyme with the potatoes. After the frittata cooks, sprinkle it with crumbled goat cheese instead of Cheddar.

1 tablespoon olive oil or butter

8 ounces fingerling potatoes, halved, or baby red potatoes, sliced

½ cup chopped ham (3 ounces)

8 large eggs

1 teaspoon salt and pepper blend

½ cup (2 ounces) Cheddar cheese

PREP AT HOME:

If desired, chop ham and grate cheese. Store in separate containers in the refrigerator.

AT CAMPSITE:

Prepare a charcoal or gas grill, or assemble a camp cookstove.

Heat oil or melt butter in a 10-inch cast-iron or nonstick skillet over medium heat. Add potatoes; cook, covered, 10 minutes, stirring occasionally. Add ham; cook until thoroughly heated, about 1 minute.

Whisk together eggs, salt, and pepper. Pour egg mixture over ham mixture. Cook, stirring gently, over medium heat until edges begin to set, about 2 minutes. Reduce heat or move to cooler side of grill. Cover with lid or foil; cook 5 minutes or until set. Sprinkle with cheese.

Cut into 6 wedges. Serve immediately.

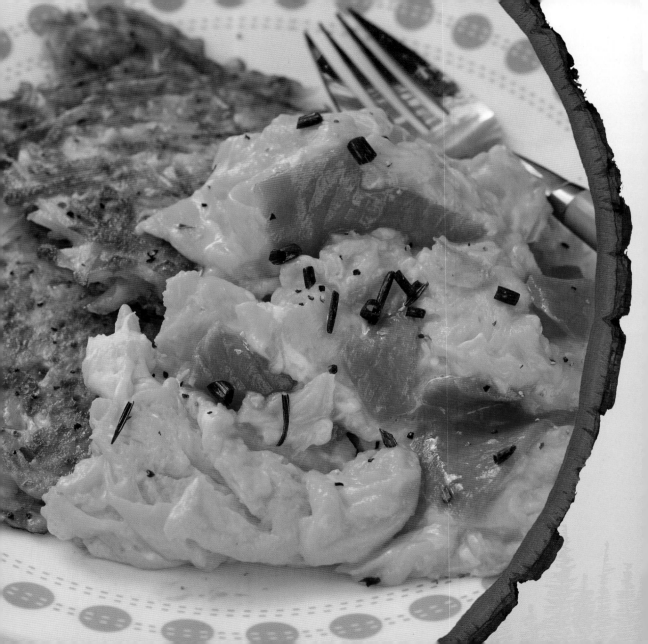

ADDING LIQUID to the eggs is optional but creates steam, which makes them fluffy. Half-and-half makes them extra creamy, but even plain water works. Cold or hot smoked salmon will be delicious—use your favorite. For a tasty side dish, serve these eggs with the Cheesy Potato Cakes (page 35).

8 large eggs

¼ cup half-and-half or milk or water

2 tablespoons butter

1 (3- to 4-ounce) package cold or hot smoked salmon

1 teaspoon chopped chives

Salt and pepper

AT CAMPSITE:

Prepare a charcoal or gas grill, or set up a propane cookstove.

Whisk together eggs and half-and-half.

Melt butter in a large nonstick skillet over medium heat. Add egg mixture. Cook eggs, stirring gently with a silicone spatula, 3 to 5 minutes or until just set. Remove from heat and stir in salmon. Sprinkle with chives, and salt and pepper to taste.

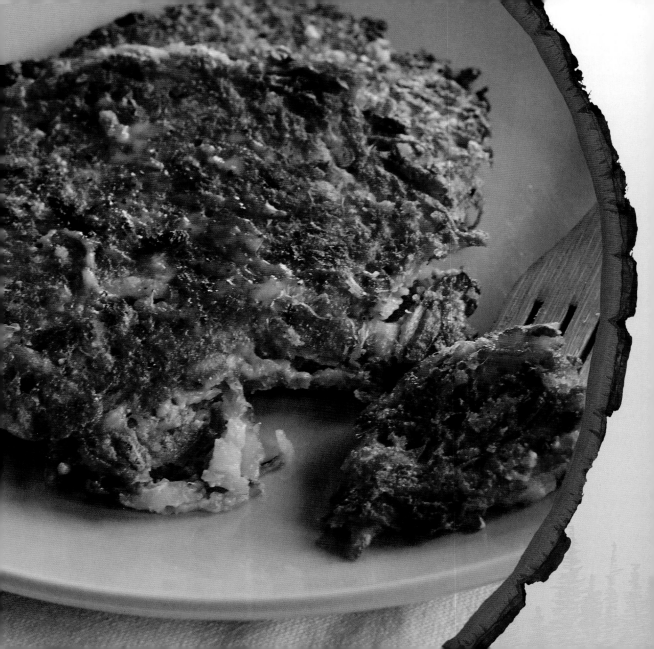

CHEESY POTATO CAKES

1 large russet potato

1 large egg

¼ cup grated Parmesan or Romano cheese

1 tablespoon all-purpose flour

Salt and pepper

Olive or canola oil

PREP AT HOME:

Grate cheese and combine with flour. Store in an airtight container in the refrigerator.

AT CAMPSITE:

Assemble a camp cookstove or prepare a charcoal or gas grill.

Grate potato into a bowl. Stir in egg, cheese, flour, and salt and pepper to taste.

Heat a thin layer of oil in a nonstick skillet over medium heat. Working in batches, drop heaping tablespoons into skillet and flatten into small cakes. Cook 3 to 5 minutes; turn over and cook 2 to 4 minutes until golden brown. Repeat with remaining 1 teaspoon oil and remaining potato mixture. Season with additional salt and pepper, if desired.

Variation: Stir in up to 2 tablespoons chopped onion and 1 tablespoon chopped fresh herbs. This is a great place to use leftover bits of vegetables and herbs for flavor.

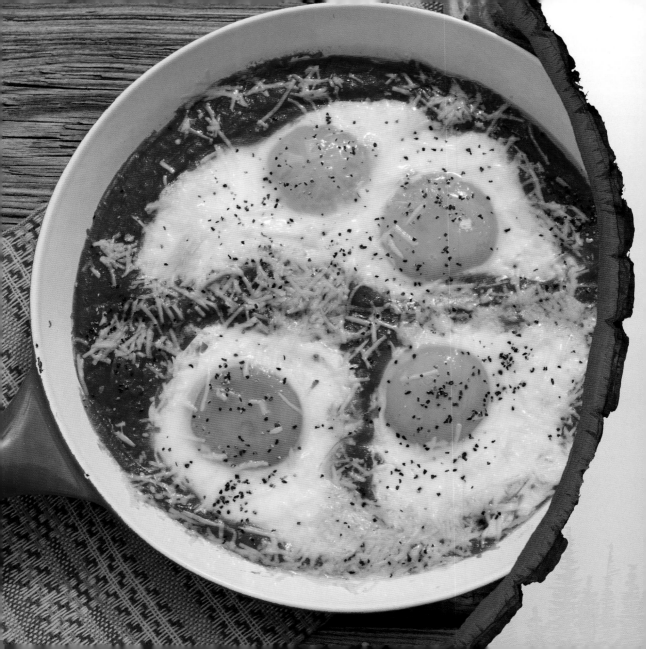

THIS SUPER–HEARTY breakfast dish isn't as spicy as it sounds, but you can add more punch and protein with hot sausage.

1 tablespoon olive oil

2 garlic cloves, minced

⅛ to ¼ teaspoon dried chili flakes

2 cups store-bought marinara or spaghetti sauce

4 large eggs

¼ cup (1 ounce) grated Parmesan cheese

Salt and pepper

4 to 8 slices toast

PREP AT HOME:

Grate cheese. Store in an airtight container.

AT CAMPSITE:

Prepare a charcoal or gas grill, or assemble a camp cookstove.

Heat oil in a 10-inch heavy skillet over medium heat. Add garlic and chili flakes. Cook 1 minute. Stir in sauce. Cook 3 to 5 minutes, stirring occasionally, until simmering.

Crack eggs into sauce; sprinkle with cheese. Cover with lid and cook 3 minutes or until desired degree of doneness. Season with salt and pepper to taste. Serve eggs with toast.

Variation: Add 1 hot or Italian sausage link, casing removed, to garlic and chili flakes. Cook 5 minutes or until browned and crumbling. Stir in sauce and continue with recipe as directed.

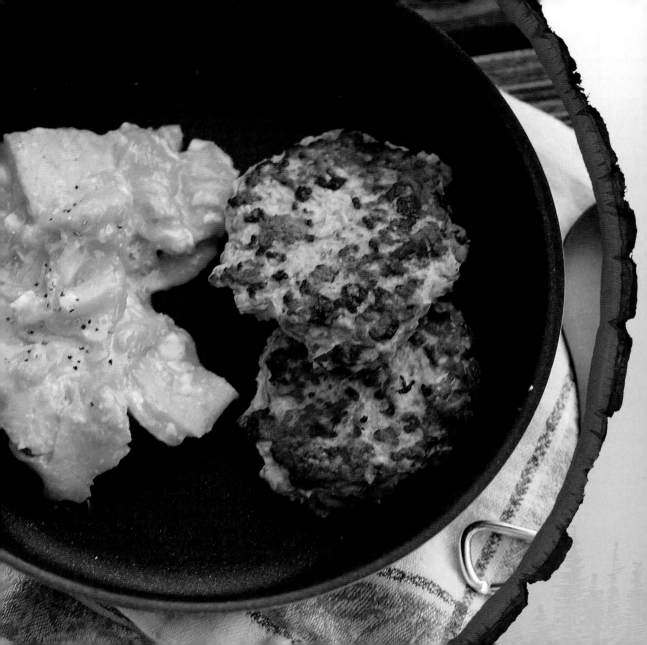

THIS FAMILY FAVORITE disappears quickly. It's versatile—you can assemble all of the ingredients at camp or at home (and have less bowls to wash at camp). Separate each uncooked patty with a piece of parchment paper or clear plastic wrap before freezing. Patties can get tough if overcooked during reheating, so use low heat.

Canola oil or cooking spray

1 pound lean ground turkey

½ small apple, finely chopped, or ¼ cup chopped dried apple

½ cup quick-cooking or old-fashioned oats

1 (4-ounce) can diced green chilies, drained

1 large egg

1 ½ teaspoons dried sage

1 teaspoon salt

¼ teaspoon coarse-ground black pepper

PREP AT HOME:

Combine ground turkey, apple, oats, chilies, egg, sage, salt, and pepper in a large bowl. Shape mixture into 12 patties. If freezing raw, place parchment paper or clear plastic wrap between each one to avoid sticking when thawed.

If cooking ahead, heat oil or cooking spray in a nonstick skillet. Cook sausages, in batches, 2 to 3 minutes on each side or until browned and completely done. Cool.

Wrap in plastic wrap and foil. Refrigerate up to 3 days or freeze up to 3 months.

AT CAMPSITE:

If cooking from raw, heat oil or cooking spray in a nonstick skillet. Cook prepared patties (ground turkey, apple, oats, chilies, egg, sage, salt, and pepper combined and shaped), in batches, 2 to 3 minutes or until browned and completely done.

Reheat cooked sausage patties over a grill grate, campfire, or in a large nonstick skillet for 2 to 3 minutes on each side or until heated through.

PIMIENTO CHEESE DROP BISCUITS

4 SERVINGS (4 BISCUITS); WPS = 4 OZ.

½ cup Pimiento Cheese Spread (page 75) or purchased pimiento cheese

½ cup milk

1 cup Basic Baking Mix (page 239) or prepared baking mix

Butter or shortening

PREP AT HOME:

Prepare Pimiento Cheese Spread; store in an airtight container in the refrigerator.

Prepare Basic Baking Mix; store in an airtight container.

AT CAMPSITE:

Remove pimiento cheese from cooler and let soften.

Prepare a charcoal or gas grill for indirect heat or prepare a campfire.

Stir together softened cheese and milk. Fold in baking mix. Coat a heavy skillet with butter or shortening and heat over medium-high heat. Drop heaping tablespoons of dough onto hot skillet. Cook 1 minute or until firm on bottom. Move skillet to cool section of grill. Turn biscuits over and cook, covered, for 10 to 15 minutes or until cooked through.

- 2 cups bread flour or all-purpose flour
- 1 (¼-ounce) package or 2 ¼ teaspoons active dry yeast
- 2 teaspoon sugar
- 1 teaspoon salt
- ¾ to 1 cup water
- 2 teaspoon oil plus more for cooking

PREP AT HOME:

Combine flour, yeast, sugar, and salt in a large plastic storage bag.

AT CAMPSITE:

Transfer flour mixture (flour, yeast, sugar, and salt) to a bowl. Add ¾ to 1 cup water to flour mixture, stirring until a soft dough forms. Drizzle oil over dough, turning to coat all sides. Cover with a damp towel.

Place in a warm spot; let rise about 1 hour or until doubled in size. Punch dough down and divide into 8 pieces. Flatten with a rolling pin, canned good, or palm of hand to form flat circles.

Assemble a camp cookstove. Heat a thin layer of oil in a skillet over medium-high heat. Stretch 1 or 2 dough pieces again and place in skillet. Cook 1 to 2 minutes until bubbles form on top. Turn over, and cook 1 to 2 minutes until puffed and golden brown.

To grill, prepare a charcoal or gas grill for medium-high heat. Stretch dough before placing on greased grill racks. Grill 1 to 2 minutes until bubbles form on top. Turn over, and cook 1 to 2 minutes until puffed and golden brown.

Appetizers, Snacks & Small Bites

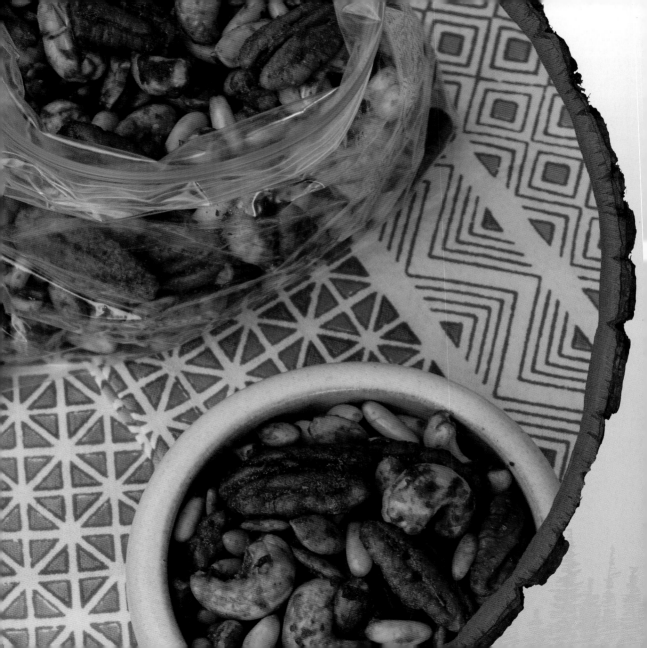

FOR A WELL-ROUNDED trail mix, stir in chopped dried fruit and chopped jerky after the nuts cool.

¼ cup butter

½ cup prepared barbecue sauce

1 to 2 tablespoons Sweet-and-Spicy BBQ Blend (page 227)

3 cups mixed nuts (pecan halves, walnut halves, slivered almonds)

PREP AT HOME:

Preheat oven to 250°. Line 2 sheet pans with nonstick aluminum foil.

Melt butter in a large skillet over medium heat. Stir in sauce and spice blend. Cook 1 to 2 minutes or until mixture is well blended. Stir in nuts.

Spread nuts on baking sheets in an even layer. Bake 40 minutes, stirring occasionally, until mixture is dry and nuts are toasted. Nuts will crisp more as they cool. Cool completely.

Store in an airtight container up to 1 month.

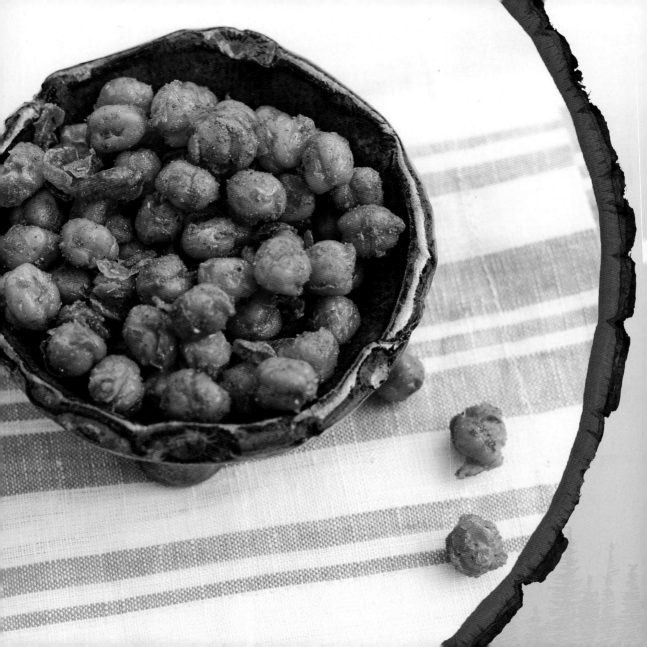

CRISPY SPICY CHICKPEAS

THESE MAKE a great snack, but also try them as toppers for salads. Use a pan with deep sides because the beans splatter a bit when first dunked in the hot oil.

1 (19-ounce) can chickpeas or garbanzo beans

Canola oil

1 tablespoon Moroccan Seasoning Blend (page 233), Sweet-and-Spicy BBQ Blend (page 227), or salt

PREP AT HOME:

Prepare seasoning blend; store in an airtight container at room temperature.

AT CAMPSITE:

Assemble camp cookstove.

Rinse and drain beans. Dry thoroughly on paper towels.

Pour oil to a depth of ¼ inch to ½ inch in a small saucepan or deep skillet over medium-high heat. Add chickpeas and cook (mixture will splatter) for 12 to 15 minutes or until chickpeas are golden brown and crispy. Remove from heat; transfer chickpeas to paper towels with a slotted spoon. Sprinkle with seasoning blend and stir gently. Cool slightly before eating.

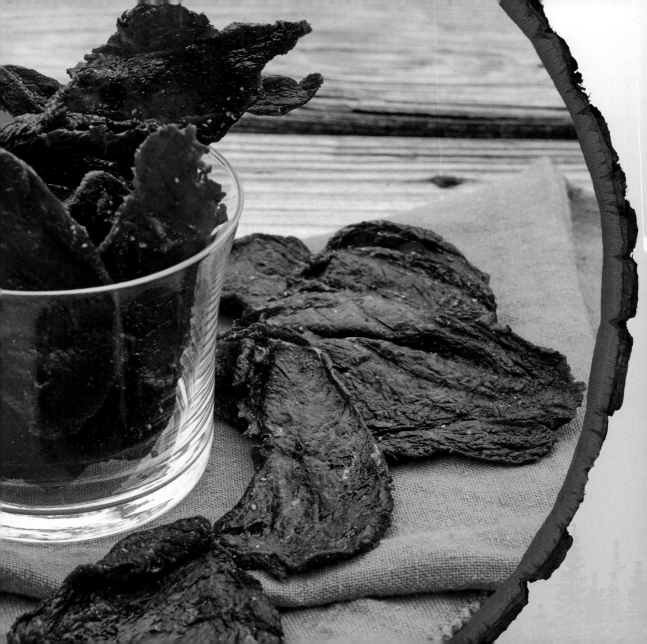

MANY CUTS of beef make fine jerky—the key is getting meat with very little interior fat to reduce the risk of spoilage. It's easy to remove fat from around the outside of the meat, but cutting it out of the center leaves odd, ragged pieces. Freezing steak slightly makes it easier to cut thin slices. Try to cut each slice at an even thickness so each one will dry at the same time. If some pieces are thicker, pound them with a meat mallet to an even thickness.

1 ½ pounds lean beef steak, such as flank, eye of round, bottom round, or top round

½ cup soy sauce

3 tablespoons Sweet-and-Spicy BBQ Blend (page 227)

2 tablespoons Worcestershire sauce

1 teaspoon liquid smoke

2 teaspoons sriracha or chili-garlic sauce (optional)

PREP AT HOME:

Trim fat from steak and place in the freezer for 30 minutes to 1 hour until firm but not frozen. Slice into ⅛-inch-thick slices. Use a meat tenderizer, if desired.

Combine soy sauce, Sweet-and-Spicy BBQ Blend, Worcestershire sauce, liquid smoke, and, if desired, sriracha in a large plastic storage bag. Add meat slices, tossing to coat. Seal and marinate in the refrigerator 6 to 8 hours or overnight.

Drain meat, discarding liquid. Pat dry with paper towels. Place meat strips in a food dehydrator according to manufacturer's directions. Dry meat 4 to 8 hours, depending on thickness. (**Note:** Some machines recommend drying up to 12 hours for beef jerky, but mine has always been done in much less time. You can also dry the jerky in a 175° oven on cooling racks, rotating periodically. Test frequently.)

Store in an airtight container or plastic storage bags up to 1 month or freeze up to 6 months.

Tip: Dried jerky should be leathery and may crack slightly when bent in half. If it snaps in two, then the jerky is overdone.

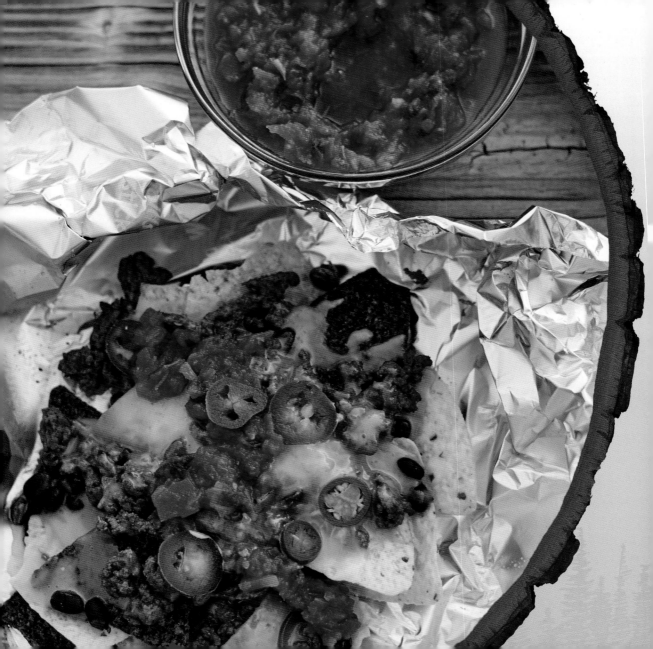

THIS IS FUN for kids and picky eaters—they can create their own foil pouches using only their favorite ingredients.

2 heaping cups blue, yellow, or white corn tortilla chips

1 cup shredded cooked chicken

1 cup (4 ounces) shredded Cheddar, Monterey Jack, or processed cheese

Fresh Tomato Salsa (page 55), Quick Smoky Salsa (page 57), or purchased salsa

TOPPINGS: sour cream and pickled jalapeño peppers

PREP AT HOME:

Shred cheeses and place in an airtight container. Store in refrigerator.

Prepare salsa. Store in an airtight container in the refrigerator.

AT CAMPSITE:

Prepare a gas or charcoal grill or wood campfire.

Tear off 2 (18-inch) pieces of heavy-duty nonstick or lightly greased aluminum foil. Divide chips equally on each sheet of foil. Top evenly with chicken and cheese.

Wrap foil pouches. Cook over medium-low heat about 5 minutes or until mixture is thoroughly heated and cheese melts. Carefully unwrap and add salsa and desired toppings.

Variations: Substitute cooked ground beef or chicken, or use corn and black beans for hearty vegetarian nachos.

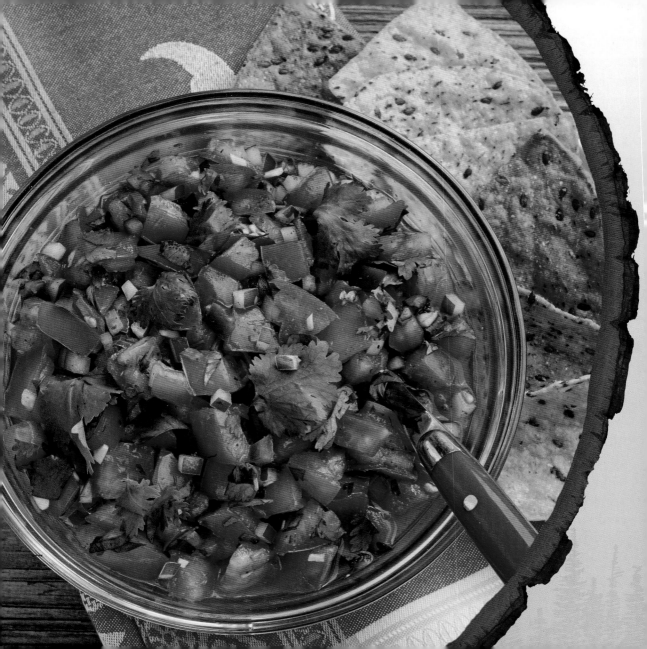

THIS CHUNKY FRESH camp salsa has a texture similar to pico de gallo. For a smooth, "restaurant-style" salsa, make ahead and puree in a food processor until somewhat smooth.

3 large ripe tomatoes, seeded and chopped

¼ red onion, chopped

1 small jalapeño pepper, minced (optional)

1 garlic clove, minced

¼ cup chopped fresh cilantro

1 teaspoon Mexican or Taco Seasoning Blend (page 229) or ½ teaspoon ground cumin and ½ teaspoon salt

1 to 2 limes

PREP AT HOME:

Note: Salsa may be prepared a day or two ahead, but the mixture may lose flavor after it sits. If so, stir in additional seasoning or lime juice before serving.

AT CAMPSITE:

Combine tomatoes, onion, jalapeño, garlic, cilantro, and seasoning blend in a large bowl. Cut lime in half and squeeze juice into salsa, stirring to blend. Adjust seasonings, if necessary.

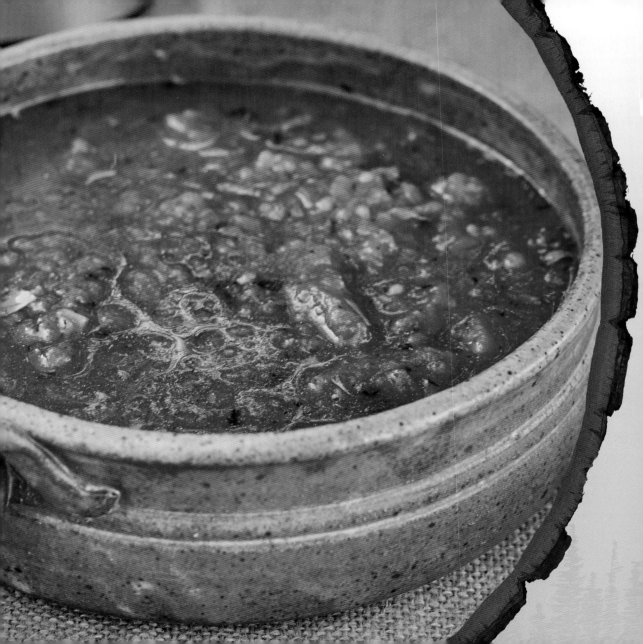

1 (14.5-ounce) can fire-roasted diced tomatoes, undrained

2 to 3 teaspoons chopped chipotle peppers in adobo sauce

1 large lime (2 tablespoons juice plus 1 teaspoon zest)

¼ cup fresh cilantro leaves, chopped, or 2 tablespoons dried cilantro

½ teaspoon salt (optional)

PREP AT HOME:

To make ahead and for a finer texture, combine all ingredients in a food processor. Pulse until well blended.

AT CAMPSITE:

Combine canned tomatoes and chipotle peppers in a medium bowl.

Grate lime zest into bowl. Cut lime in half and squeeze juice into bowl.

Coarsely chop cilantro and stir into tomato mixture.

Season with salt to taste, if desired.

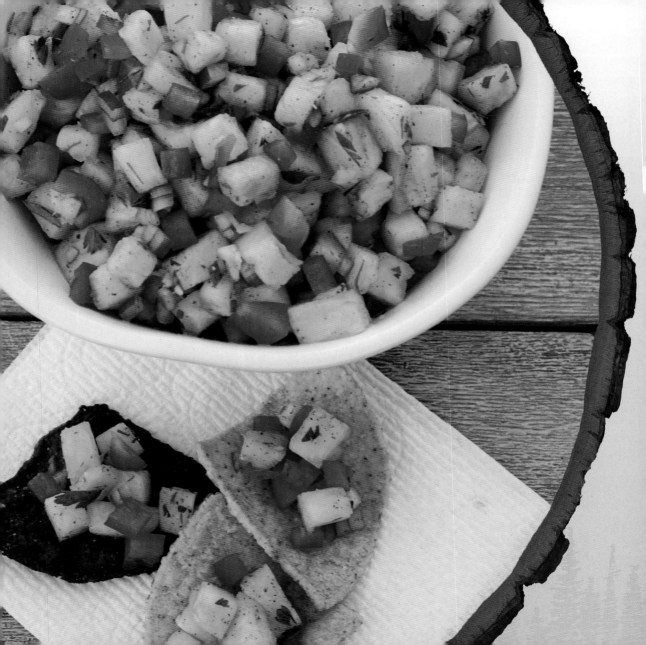

PINEAPPLE SALSA

NOT ONLY IS IT A TASTY snack on tortilla chips, but this zesty fruit salsa is also a delicious pairing with grilled meats or grilled fish tacos. When made fresh, the sour pineapple flavor really shines. When made ahead, the fruit mellows a bit, and you taste more of the seasoning blend.

1 small pineapple, coarsely chopped

1 small red bell pepper, coarsely chopped

1 jalapeño, seeded and minced (optional)

¼ cup minced red onion

¼ cup chopped fresh cilantro

2 teaspoons Sweet-and-Spicy BBQ Blend (page 227)

2 tablespoons fresh lime juice

PREP AT HOME:

Prepare Sweet-and-Spicy BBQ Blend. If desired, combine remaining ingredients in a glass or plastic container or plastic storage bag; cover and store in the refrigerator.

AT CAMPSITE:

Combine all ingredients in a nonaluminum container.

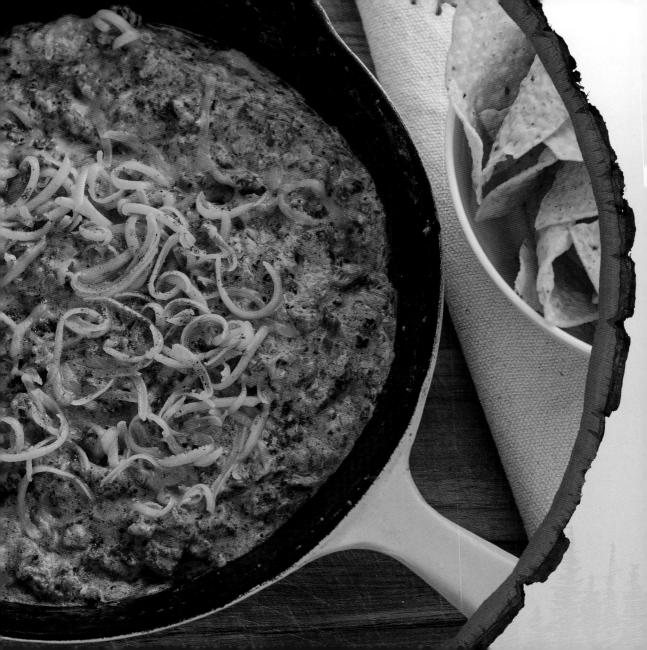

1 pound ground bulk hot, mild, or sage sausage

1 (8-ounce) package cream cheese

1 cup Fresh Tomato Salsa (page 55), Quick Smoky Salsa (page 57), or any purchased salsa

2 teaspoons Mexican or Taco Seasoning Blend (page 229) or taco seasoning

2 ounces (½ cup) shredded Cheddar cheese

Tortilla chips

PREP AT HOME:

Prepare Mexican Seasoning Blend, if desired.

Shred cheese; store in an airtight container in the refrigerator.

AT CAMPSITE:

Prepare a charcoal or gas grill, or assemble a cookstove.

Cook sausage in a medium-size (10-inch) heavy skillet over medium-low heat, stirring frequently, 8 to 10 minutes or until browned and crumbled. Drain, if necessary.

Add cream cheese, salsa, and seasoning to cooked sausage. Cook 5 minutes, stirring frequently, until well blended. Top with cheese and serve with chips.

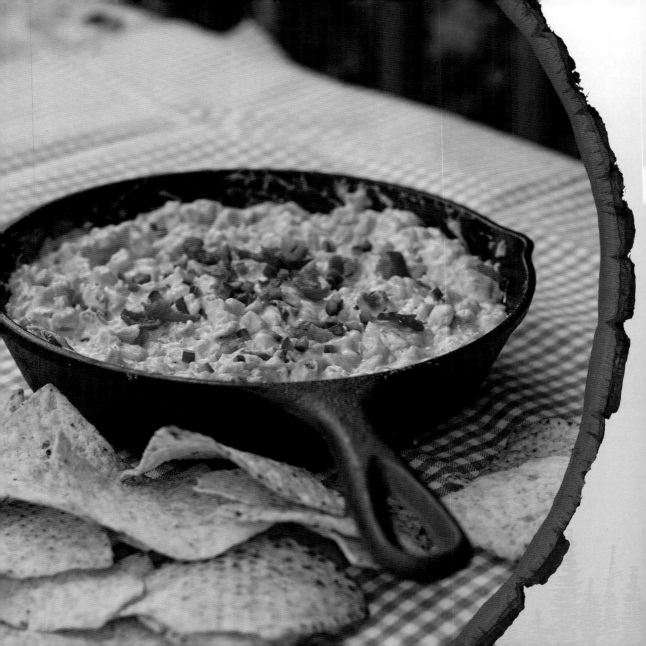

CREAMY CORN-BACON DIP

HERE'S ANOTHER crowd-pleasing recipe made as much at home as at the campsite. Fresh summer corn is amazing, but you can substitute 1 ½ cups thawed frozen corn or 1 can of corn (rinsed and drained).

4 slices bacon, chopped

3 ears corn

2 green onions or 2 tablespoons chopped chives

1 jalapeño, seeded and minced (optional)

1 (8-ounce) package cream cheese, softened

½ cup mayonnaise

1 cup (4 ounces) shredded Cheddar cheese

Corn or tortilla chips

PREP AT HOME:

Note: The entire recipe can be prepared at home and reheated over low heat.

Shuck corn and remove silks.

Shred cheese; store in an airtight container.

AT CAMPSITE:

Prepare a charcoal, wood, or gas grill, or assemble a camping cookstove. Heat an 8- to 10-inch cast-iron skillet over medium heat.

Cook bacon until crispy. Drain bacon on a paper towel, reserving 2 teaspoons drippings in pan.

Cook corn, onions, and, if desired, jalapeño in drippings 3 to 5 minutes or until hot and just starting to brown on edges. Move skillet to low heat, or reduce heat to low. Stir in cream cheese and mayonnaise. Cook, stirring constantly, 5 minutes or until hot and well blended. Stir in bacon and Cheddar cheese. Serve with chips.

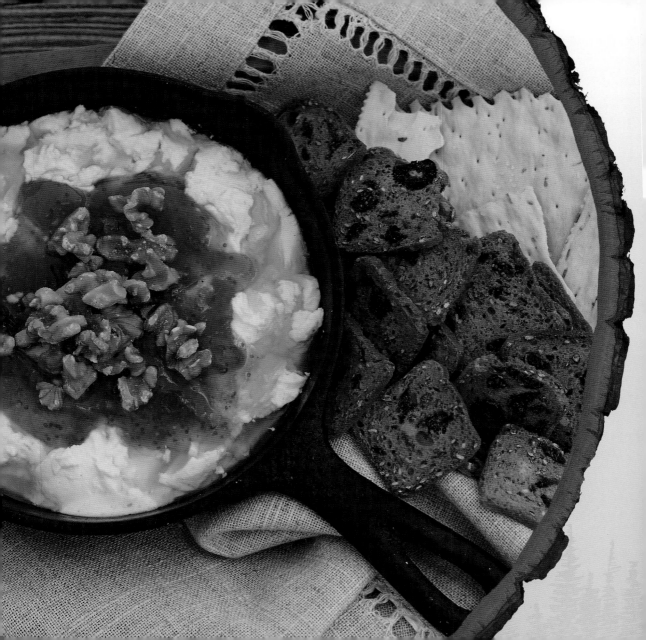

GRILLED GOAT CHEESE AND FIG FONDUE

THIS SURPRISINGLY EASY appetizer feels rustic and upscale at the same time. It makes a delicious midafternoon snack when you want something satisfying but you're not ready for dinner.

1 (10- to 11-ounce) log goat cheese, softened

½ cup fig preserves or jam (or more to taste)

¼ teaspoon cracked black pepper

2 tablespoons chopped toasted walnuts, pistachios, or almonds

Flatbread crackers, crostini, or French bread slices

PREP AT HOME:

Toast nuts, if desired, in a 350° oven for 5 minutes until light golden brown; cool completely.

AT CAMPSITE:

Prepare a charcoal or gas grill or campfire.

Spread cheese in bottom of a 6 ½-inch, well-seasoned or lightly greased cast-iron skillet. Cook over medium heat, stirring occasionally, 5 to 7 minutes or until bubbly.

Spoon fig preserves into center of cheese, and sprinkle with pepper and nuts. Serve with crackers, crostini, or bread.

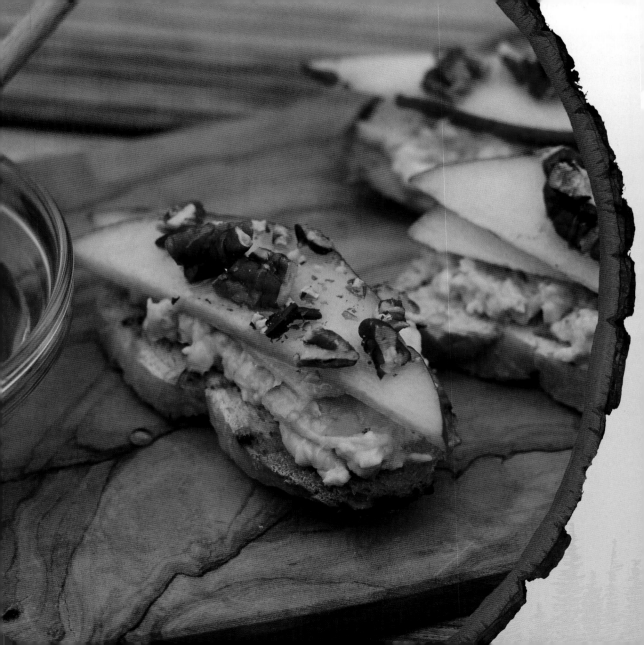

HERE'S ANOTHER sweet–salty combo that proves how cheese is made even more delicious next to a campfire.

12 (½-inch) slices French baguette

1 ripe pear or apple, thinly sliced

2 tablespoons butter, softened

½ cup (2 ounces) blue cheese or Gorgonzola

2 tablespoons honey

Chopped pecans (optional)

PREP AT HOME:

Combine butter, blue cheese, and honey in a small container..

AT CAMPSITE:

Prepare a gas or charcoal grill or campfire.

Grill bread slices over medium-high heat about 2 minutes on each side or until golden brown.

Very thinly slice pear or apple. Combine butter, blue cheese, and honey; spread mixture evenly over bread slices and top with 3 or 4 pear slices. Drizzle with additional honey and, if desired, pecans.

Variation: Upscale it to a full meal when you spread the blue cheese mixture on 2 slices of sourdough bread and add a slice of smoked ham or a few slices of prosciutto. Butter the outside of the bread, and toast the sandwich like a traditional grilled cheese.

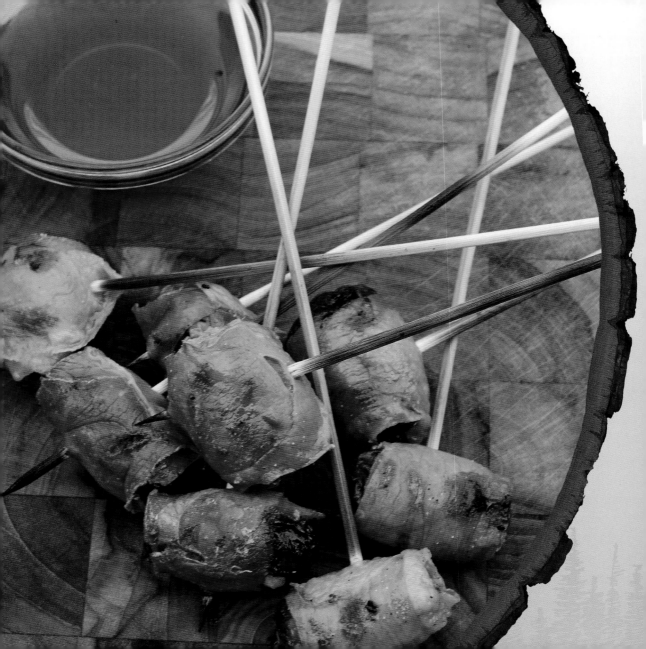

THIS TASTY LITTLE snack is addictive! Prosciutto is a type of Italian dry-cured ham. It's usually eaten raw because its low water content prevents bacterial growth; however, in this recipe it's cooked until it's slightly crispy around the sweet date. To reduce sodium, substitute Swiss cheese and low-sodium deli ham. You may also use dried figs instead of dates.

8 large dates, pitted

1 ounce Manchego or Parmesan cheese

4 slices prosciutto (about 2.5 ounces)

¼ cup maple syrup

PREP AT HOME:

Cut cheese into 8 thin rectangular pieces, about ¼ inch x ¾ inch. Slice prosciutto lengthwise in half.

Cut the side of each date and open slightly (remove pits, if present). Insert 1 piece of cheese. Wrap each stuffed date with prosciutto. Store in an airtight container in the refrigerator.

AT CAMPSITE:

Soak wooden skewers in water at least 30 minutes, if using.

Prepare a wood campfire or charcoal or gas grill for medium-high heat.

Thread 2 prepared dates (opened and stuffed with cheese, then wrapped in prosciutto) onto each skewer. Grill over fire, turning frequently, until prosciutto is crisp and cheese begins to melt. Serve immediately, drizzled with maple syrup.

Note: If you want to make this at home, wrap dates and place on a foil-lined pan in a toaster oven. Bake at 375°, turning once, until prosciutto crisps and cheese just starts to melt.

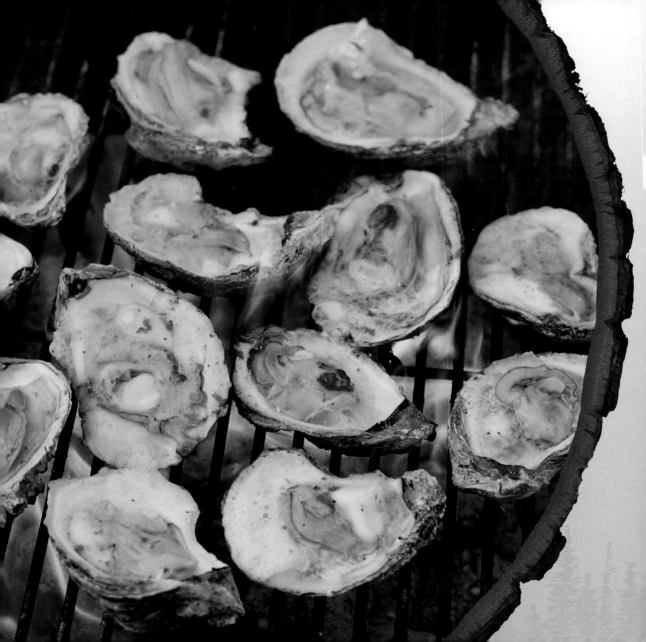

GRILLED OYSTERS WITH GARLIC AND PARMESAN

BE READY for a few flare-ups, as the butter may drip over the sides into the heat. The extra char on the edge of the shells adds to the flavor!

2 dozen fresh oysters

½ cup butter, softened

¼ cup freshly grated Parmesan cheese

3 garlic cloves, minced

1 teaspoon Lemon-Pepper Blend (page 235) or grated lemon zest

PREP AT HOME:

Combine butter, cheese, garlic, and seasoning in a small bowl.

AT CAMPSITE:

Prepare charcoal or gas grill for high heat.

Shuck oysters, keeping as much liquid in the shell as possible.

Combine butter, cheese, garlic, and seasoning. Top each oyster with ½ to 1 teaspoon butter mixture (save extra butter mixture for other uses). Grill oysters 5 minutes or just until edges begin to curl and sauce begins to bubble.

Sandwiches
& Soups

GRILLED PIMIENTO CHEESE SANDWICHES

4 SERVINGS; WPS = 8 OZ.

MAKE extra Pimiento Cheese Spread because someone usually wants a second helping. It's also great on top of sliders (page 93); stirred into biscuits for a rich, cheesy breakfast; or as a replacement for Cheddar for really interesting nachos.

4 cups (16 ounces) shredded sharp Cheddar cheese

4 ounces reduced-fat cream cheese or Neufchâtel, softened

⅔ cup regular or light mayonnaise

1 teaspoon grated onion

2 teaspoons Worcestershire sauce

½ teaspoon hot sauce

¼ teaspoon coarse-ground black pepper

1 roasted red bell pepper, chopped, or 1 (4-ounce) jar chopped pimientos, drained

8 slices sourdough or whole grain bread

4 teaspoons softened butter or mayonnaise

PREP AT HOME:

Shred Cheddar cheese in a food processor. Set aside.

Prepare Pimiento Cheese Spread: Combine cream cheese, mayonnaise, onion, Worcestershire, hot sauce, and pepper in a food processor. Process until smooth. Add Cheddar cheese; process until blended to desired texture. Add bell pepper; pulse until combined.

Cover and chill until ready to serve. Store in the refrigerator up to 1 week.

AT CAMPSITE:

Prepare a gas or charcoal grill or set up camp stove.

Spread about ⅓ to ½ cup prepared Pimiento Cheese Spread (Cheddar cheese, cream cheese, mayonnaise, onion, Worcestershire, hot sauce, pepper, and bell pepper) on 4 slices bread; top with remaining 4 slices bread. Spread outside of sandwiches with a thin layer of butter.

Grill sandwiches on grill grate or in a nonstick skillet over medium-high heat for 2 minutes on each side or until golden brown.

SANDWICHES & SOUPS **75**

HUMMUS VEGGIE WRAPS

1 medium zucchini

1 cup lightly packed spinach leaves

¼ cup jarred roasted bell peppers, drained and sliced into strips

⅓ cup plain hummus

2 (10-inch) multigrain wraps or whole wheat flour tortillas

⅓ cup crumbed feta cheese

1 teaspoon chopped fresh oregano

½ teaspoon coarse-ground black pepper

PREP AT HOME:

Stir together feta, oregano, and pepper. Store in an airtight container until ready to use.

AT CAMPSITE:

Slice ends from zucchini and cut lengthwise into thin ribbons using a vegetable peeler or mandolin. Combine zucchini, spinach, and bell pepper.

Spread hummus evenly on each tortilla. Divide zucchini mixture equally over hummus. Top with prepared feta mixture (feta, oregano, and black pepper). Roll tightly; cover in plastic wrap and refrigerate until ready to serve.

Variation: Thinly slice 1 cooked boneless chicken breast, and divide evenly among tortillas before rolling.

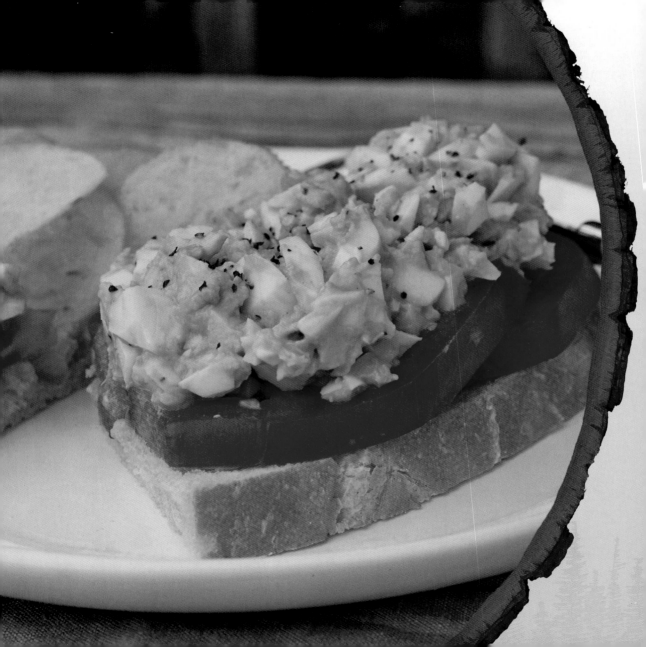

OPEN-FACED AVOCADO-EGG SALAD SANDWICHES
2 SERVINGS; WPS = 14 OZ.

2 slices bread, toasted

1 ripe avocado, coarsely chopped

1 lemon

2 hard-cooked eggs, peeled and coarsely chopped

Salt and pepper

Spinach leaves

1 medium tomato, sliced

PREP AT HOME:

Cook eggs by placing them in simmering water to cover. Bring to a boil; cover, then remove from heat. Let stand 10 minutes. Peel and store in refrigerator.

AT CAMPSITE:

Toast bread over a campfire or grill.

Mash avocado slightly in a large bowl. Cut lemon and squeeze juice into bowl; stir to blend.

Stir chopped eggs into avocado mixture. Season with salt and pepper to taste.

Divide spinach and tomato slices evenly on bread. Top with avocado-egg salad mixture.

Variation: Meat and seafood lovers can add chopped bacon or smoked salmon to avocado-egg salad mixture for an extra-hearty meal.

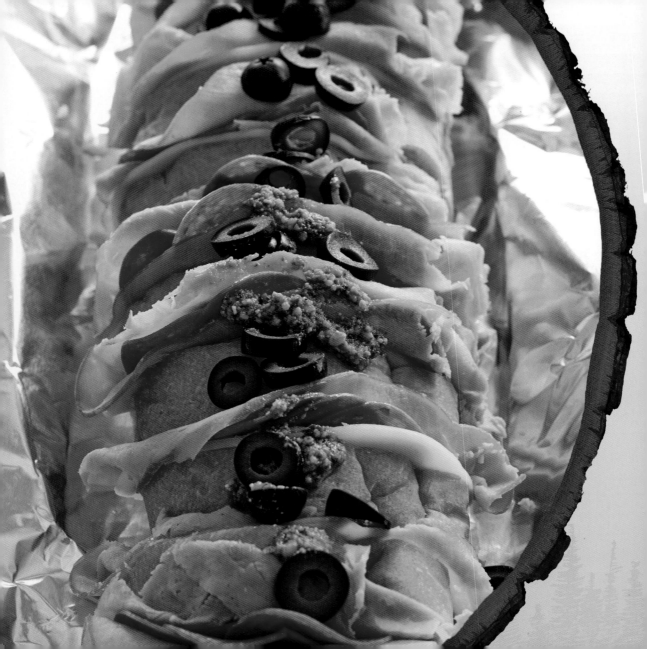

1 (14-ounce) loaf unsliced Italian bread

8 ounces sliced provolone or smoked provolone cheese

8 ounces thinly sliced deli ham

½ (8-ounce) package sliced pepperoni

¼ to ½ cup refrigerated prepared pesto

⅓ cup chopped black olives or chopped pepperoncini

PREP AT HOME:

If serving in a day or less, assemble entire loaf and wrap in heavy-duty nonstick aluminum foil.

AT CAMPSITE:

Prepare a charcoal or gas grill, or light a campfire.

Slice bread every ¾ to 1 inch, almost to the bottom. Fold cheese in half and place evenly in between each slice of bread. Repeat with ham. Insert pepperoni evenly in between slices. Dollop pesto evenly along bread. Sprinkle with black olives or pepperoncini.

Wrap loaf in heavy-duty aluminum foil (nonstick works best). Grill loaf over medium-low heat 15 to 20 minutes, rotating occasionally. Or place in a warm spot around campfire but not in flames. Carefully open foil, and pull loaf apart to serve.

Variation: For a flavor boost, drizzle oil and vinegar or Italian salad dressing on the sandwich after cooking.

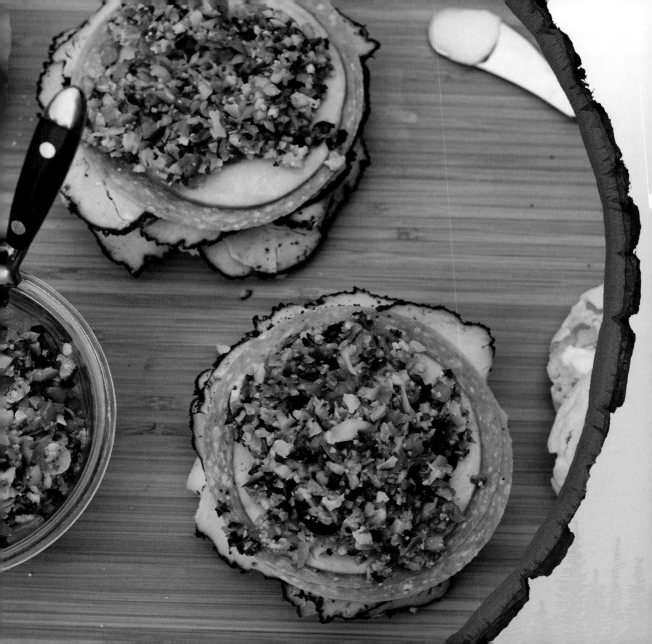

THESE NEW ORLEANS specialties are typically prepared as an extra-large, whole sandwich; however, when camping or picnicking, individual ones are easier to pack and eat. Toasting the muffins keeps the bread from getting soggy. Wrap in aluminum foil and reheat on a grill or campfire.

4 English muffins, toasted

Creole or Dijon mustard

Mayonnaise

4 slices smoked provolone or Muenster cheese

4 slices Canadian bacon

12 slices smoked turkey

4 slices large salami

½ to ¾ cup Olive Salad (recipe below)

PREP AT HOME:

Prepare Olive Salad; store in an airtight container in the refrigerator up to 1 week.

Toast English muffins until light golden brown.

Spread bottom halves with mustard and mayonnaise. Layer cheese and meats evenly on each bottom half, and top each with 2 to 3 tablespoons Olive Salad. Add top halves of muffins, and wrap each sandwich in aluminum foil to make a packet. Store in the refrigerator until ready to eat.

AT CAMPSITE:

Prepare a charcoal or gas grill for medium heat, or prepare a campfire. Place prepared sandwich packets (English muffins spread with mustard and mayonnaise, then layered with cheese, meats, and Olive Salad) on grill and cook 3 to 5 minutes, turning occasionally, or until heated.

Olive Salad

Combine ½ cup green olives with pimientos, ½ cup black olives, ½ cup pickled mixed vegetables (giardiniera), 2 tablespoons olive oil, 1 minced garlic clove, and ½ teaspoon freeze-dried Italian seasoning in a food processor; pulse until finely chopped. Store in an airtight container in the refrigerator up to 1 week. Makes 1 ½ cups.

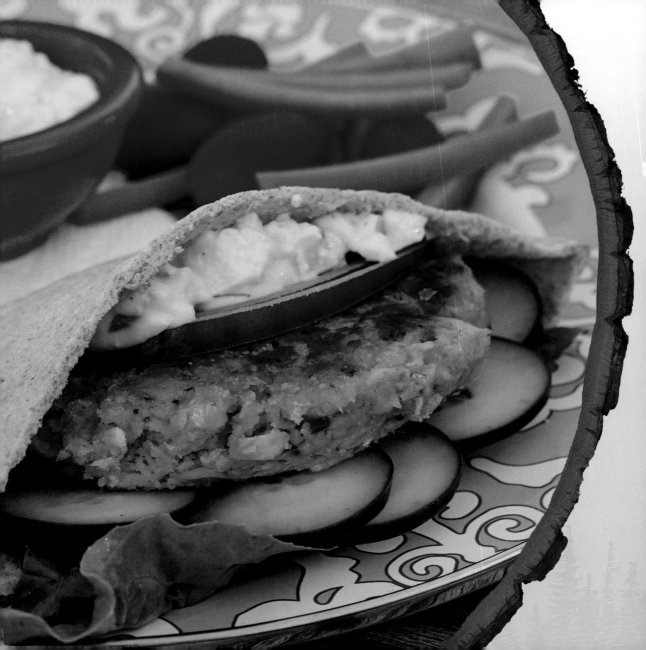

Pita bread is a great camping option because it's less likely to get crushed.

1 (14.75-ounce) can pink salmon, drained

⅓ cup plain Greek yogurt

1 large egg

1 teaspoon Dijon mustard

¾ teaspoon Lemon-Pepper Blend (page 235) or salt and pepper

½ cup panko breadcrumbs

1 tablespoon canola or olive oil

2 pita bread rounds, halved, or 4 whole wheat buns

TOPPINGS: Feta Tzatziki Sauce (recipe below), lettuce leaves, red onion and cucumber slices

PREP AT HOME:

Prepare Lemon-Pepper Blend; store in an airtight container in the refrigerator.

Feta Tzatziki Sauce may be prepared a day ahead and stored in the refrigerator. Stir before using and adjust seasoning, if necessary.

AT CAMPSITE:

Assemble a camp cookstove.

Combine salmon, yogurt, egg, mustard, Lemon-Pepper Blend, and breadcrumbs in a bowl; form mixture into 4 (½-inch-thick) patties.

Heat oil in a nonstick skillet over medium heat. Cook patties 4 to 5 minutes or until golden brown on each side. Place in pita bread and add desired toppings.

Feta Tzatziki Sauce

Combine ½ cup plain Greek yogurt; ½ cup peeled, seeded, and finely chopped cucumber; ⅓ cup crumbled feta cheese; ½ teaspoon Lemon-Pepper Blend; and ¼ teaspoon dried dill in a small container, and store in the refrigerator up to 1 day. Stir before using. Makes 1 cup.

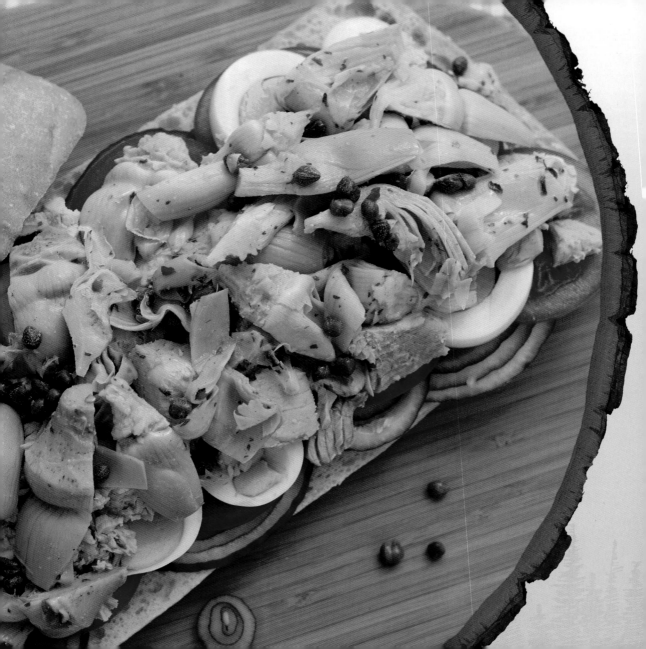

THE FRENCH LUNCH DISH, pan bagnat, is a sandwich typically filled with veggies, hard–cooked eggs, anchovies, tuna, and olive oil. It makes a great camping sandwich because it is supposed to get pressed down! It gets better as it sits, as the flavors marry and tenderize the crusty bread. Our version swaps salmon for tuna, but use tuna if that's what you love. Even shredded chicken would be tasty.

2 (6.5-ounce) jars marinated artichoke hearts, undrained

2 teaspoons coarse ground Dijon mustard

1 (16-ounce) rustic bread loaf or 10-inch-long ciabatta, split

2 small tomatoes, thinly sliced

4 thin slices red onion

2 (6-ounce) cans pink salmon, drained

2 hard-cooked eggs, peeled and thinly sliced

2 teaspoons capers, drained

PREP AT HOME:

Drain artichoke hearts, reserving ¼ cup liquid in a small bowl. Whisk mustard into reserved liquid.

Scoop out some of the soft interior of the bread loaf top to form a cavity; spread mustard mixture on cut sides of bread. Layer tomatoes and onion evenly over bottom half of bread. Break up pieces of salmon; layer on top. Top with egg slices, capers, and reserved artichoke hearts. Cover with top of bread loaf, pressing down lightly.

Wrap sandwich in plastic wrap; then place in a plastic storage bag and seal, removing as much air as possible. Store in the refrigerator or cooler 4 to 12 hours. (After placing it in the cooler, top the sandwich with a plate and weigh it down with canned goods or other items.)

AT CAMPSITE:

Unwrap prepared sandwich (bread loaf split and spread with mustard mixture [reserved liquid from artichoke hearts and mustard] and layered with tomatoes, onion, salmon, sliced eggs, capers, and artichoke hearts); slice into 4 pieces.

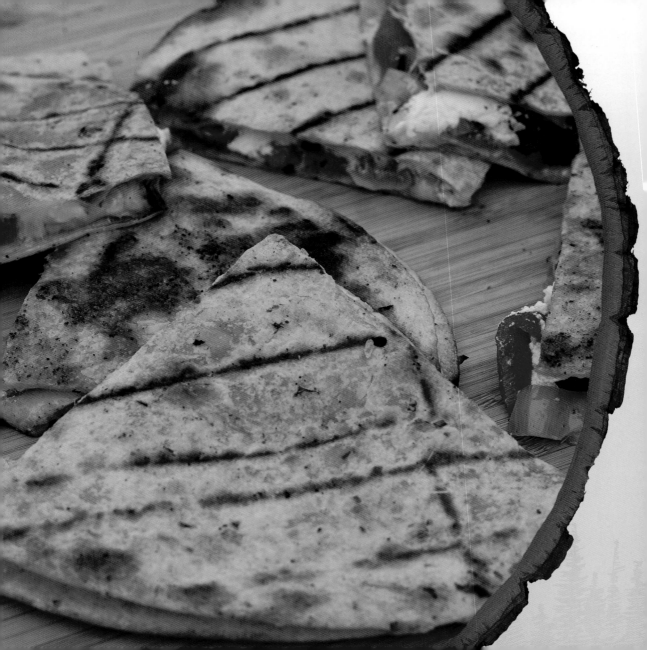

GRILLED VEGGIE QUESADILLAS

1 bell pepper

1 small onion

1 small zucchini

1 small yellow squash

1 tablespoon olive oil

½ teaspoon Mexican or Taco Seasoning Blend (recipe page 229)
 or ¼ teaspoon ground cumin and ¼ teaspoon salt

4 (8-inch) whole grain flour tortillas

1 cup (4 ounces) shredded Monterey Jack cheese

2 ounces crumbled goat cheese

PREP AT HOME:

Cut pepper in half; remove seeds. Slice onion into wedges. Remove ends from zucchini and yellow squash. Slice in half, then cut into large pieces.

Combine pepper, onion, and squash in a large plastic storage bag. Add oil and seasoning blend, tossing to coat. Store in refrigerator up to 1 day.

Combine cheeses in a small plastic storage bag. Store in refrigerator.

AT CAMPSITE:

Prepare a charcoal or gas grill for medium-high heat.

Grill prepared vegetables (bell pepper, onion, zucchini, and yellow squash tossed in olive oil and seasonings) 5 to 7 minutes, turning occasionally until tender. Cool slightly; cut into bite-size pieces.

Top 2 tortillas evenly with vegetable mixture. Combine cheeses, and divide evenly over vegetables. Place remaining tortillas over cheese; press down gently. Place each quesadilla between 2 pieces of nonstick or lightly greased aluminum foil. Seal edges to form packets.

Grill quesadilla packets over medium heat for 2 minutes. Carefully flip over with a large spatula. Grill 2 minutes until cheese melts. Cut into wedges.

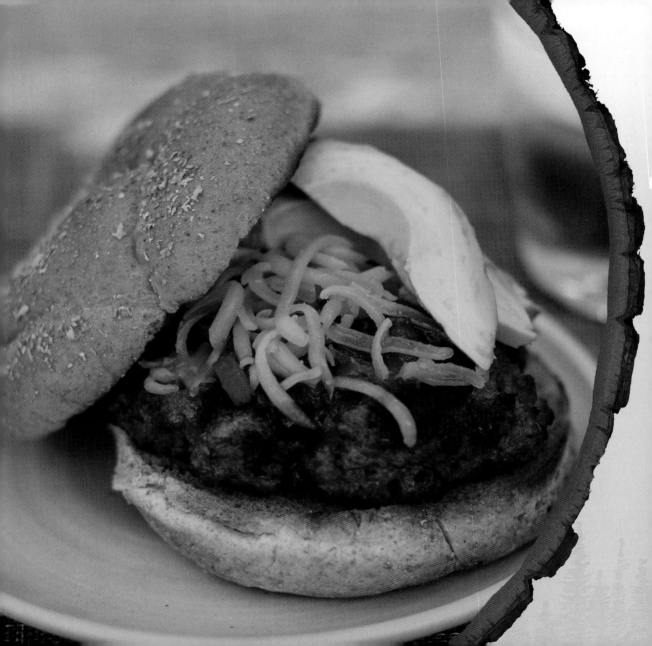

A DOLLOP of jam or jelly might seem odd on a burger, but it adds a delicious new dimension to the spicy–salty mix. There are few gourmet onion jams in stores, but you may have more success finding pepper jelly.

1 pound 80% lean ground beef

2 tablespoons chopped pickled jalapeños

3 tablespoons chopped roasted bell peppers or pimientos

2 teaspoons Mexican or Taco Seasoning Blend (page 229)

¼ cup bacon-onion jam or pepper jelly (optional)

1 small avocado, sliced (optional)

1 cup (4 ounces) shredded Cheddar or Pepper Jack cheese

4 hamburger buns

PREP AT HOME:

Combine beef, jalapeños, bell pepper, and seasoning blend; shape into 4 patties. Place in an airtight container and refrigerate up to 2 days.

AT CAMPSITE:

Prepare a charcoal or gas grill for medium-high heat or assemble a camp cookstove.

Grill or cook prepared patties (beef, jalapeños, bell pepper, and seasoning blend combined and shaped), covered, for 5 minutes. Turn over, and grill or cook 2 to 3 minutes or until desired degree of doneness. Top each burger with 1 to 3 teaspoons onion jam and avocado, if desired, and shredded cheese.

Grill buns, cut sides down, for 1 minute or until toasted. Place burgers in toasted buns.

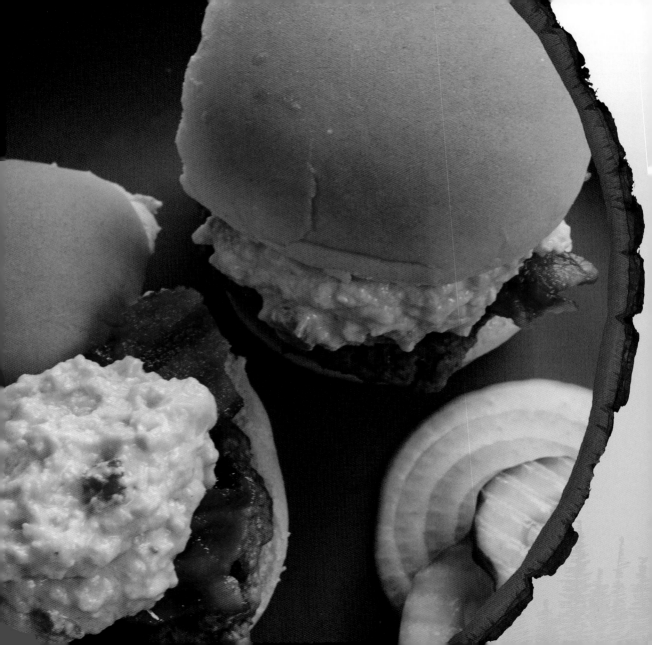

PIMIENTO CHEESE SLIDERS

4 SERVINGS; WPS = 9.5 OZ.

1 pound 80% lean ground beef

1 tablespoon Sweet-and-Spicy BBQ Blend (page 227), Mexican or Taco Seasoning Blend (page 229), or taco seasoning mix

½ cup Pimiento Cheese Spread (page 75)

8 slider rolls, split and toasted, if desired

TOPPINGS: thinly sliced onion, sliced tomato, lettuce, pickles, cooked bacon

PREP AT HOME:

Prepare spice blend; store in an airtight container.

Prepare Pimiento Cheese Spread; store in an airtight container in the refrigerator.

AT CAMPSITE:

Prepare a charcoal or gas grill for high heat or assemble a camp cookstove.

Combine beef and spice blend. Shape into 8 small patties. Grill or cook burgers over medium-high heat for 3 to 4 minutes on each side or until desired degree of doneness. Top each with 1 tablespoon Pimiento Cheese Spread; grill or cook 1 minute or until cheese starts to melt.

Serve on rolls with desired toppings.

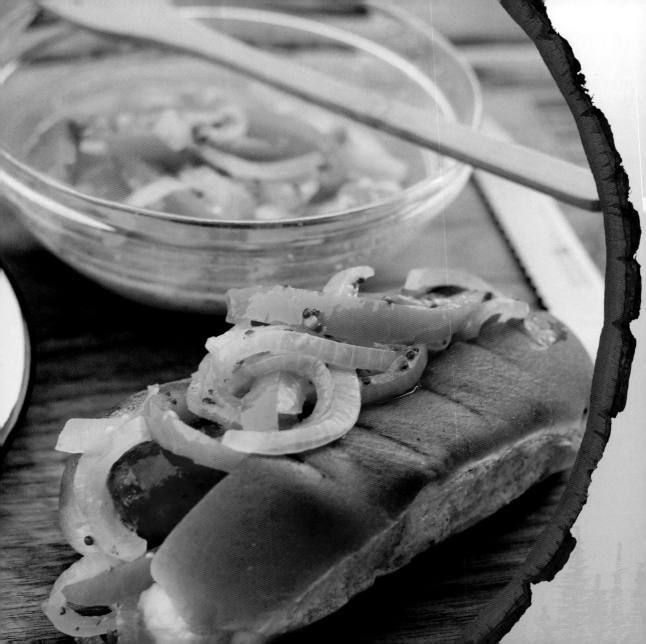

3 tablespoons butter

1 red, yellow, or orange bell pepper

1 onion

⅛ teaspoon crushed red pepper flakes

1 ½ cups (12 ounces) hard apple cider or beer

6 fresh or smoked bratwursts

1 tablespoon coarse-grain mustard

6 top-loading hot dog buns, split

PREP AT HOME:

Slice bell pepper and onion; combine with butter, if desired. Store in an airtight container in the refrigerator.

AT CAMPSITE:

Assemble camp cookstove.

Melt butter in a large skillet over medium-high heat. Add pepper and onion; cook, stirring frequently, 5 minutes or until tender. Stir in red pepper flakes, apple cider, and brats; bring to a boil. Reduce heat to a low simmer; cover, and cook 20 minutes.

Prepare a grill for medium-high heat.

Remove brats from cider mixture. Grill 5 to 8 minutes, turning occasionally, until golden brown and slightly charred on the outside. While brats are cooking, stir mustard into apple cider mixture; simmer 10 minutes or until thickened and syrupy.

Toast hot dog buns on grill and fill each with a brat and pepper mixture.

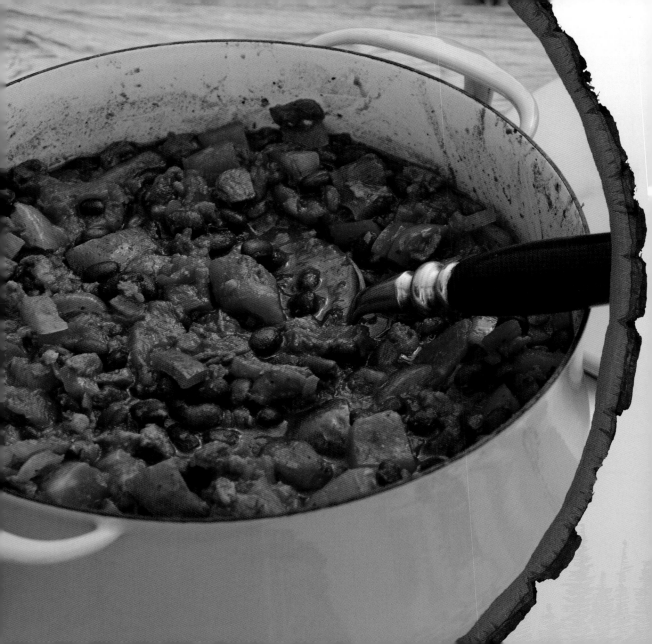

VEGETARIAN CAMPFIRE CHILI

CHIPOTLE–FLAVORED MEATLESS crumbles add heat, but any kind works well. You can also prepare this with ground beef, ground chicken, or ground turkey. Cook any of these ground meats with the onion and bell peppers until browned and crumbly. Add toppings such as sour cream and shredded cheese, if desired.

2 tablespoons olive oil

1 onion, chopped

1 red bell pepper, chopped

1 green bell pepper, chopped

1 (12-ounce) package frozen and thawed meatless crumbles

2 tablespoons Mexican or Taco Seasoning Blend (page 229) or 1.7-ounce chili seasoning mix

2 (14-ounce) cans diced tomatoes (chili seasoned or plain), undrained

2 (14-ounce) can dark or light kidney beans, rinsed and drained

Worcestershire sauce

PREP AT HOME:

Chop onion and bell peppers; store in an airtight container in the refrigerator.

AT CAMPSITE:

Prepare a charcoal or gas grill, wood campfire, or assemble a camp cookstove.

Heat oil in a 10- or 12-quart Dutch oven or soup pot. Add onion and bell peppers; cook 5 minutes, stirring occasionally.

Stir in meatless crumbles, seasoning, tomatoes, beans, and Worcestershire sauce. Cook 15 to 20 minutes, stirring occasionally.

Tip: You can also make this chili up to 3 days ahead and reheat in a heavy pan at the campsite. For backpackers or solo meals, spoon individual servings into heavy-duty plastic storage bags and freeze.

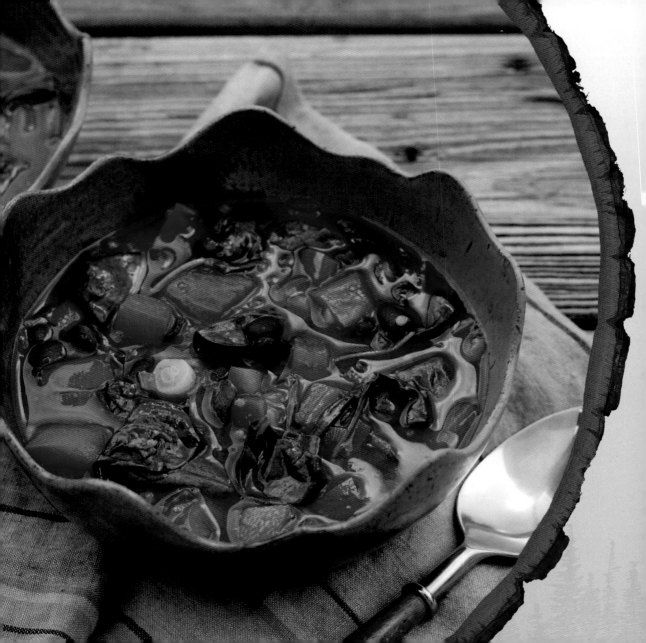

CHORIZO AND BLACK BEAN SOUP

FRESH MEXICAN chorizo is uncooked, spicy ground pork sausage that is removed from the casing and cooked like ground beef in this recipe. Portuguese chorizo is a ready-to-eat, firm-textured sausage seasoned with smoked paprika. You can substitute Portuguese chorizo, or any smoked sausage, but it will need to be sliced and cooked with a little bit of olive oil so it doesn't stick and burn.

2 (2.5-ounce) links fresh chorizo or spicy bulk pork sausage

1 onion

1 red, yellow, or green bell pepper

1 teaspoon Mexican or Taco Seasoning Blend (page 229) or ½ ground cumin and ½ teaspoon chili powder

2 chicken bouillon cubes or 1 (14.75-ounce) can chicken broth

1 (15-ounce) can black beans, rinsed and drained

1 (14.5-ounce) can diced tomatoes, undrained

2 cups chopped spinach, kale, or chard

PREP AT HOME:

Chop onion and bell pepper, if desired. Store in an airtight container.

Prepare seasoning blend.

AT CAMPSITE:

Assemble a camp cookstove.

Remove casing from chorizo and place in a Dutch oven or soup pot. Cook over medium-high heat 3 minutes or until sausage is browned and crumbled. Add onion, bell pepper, and seasoning blend. Cook 5 minutes, stirring occasionally, until vegetables are tender.

Stir in broth or 2 bouillon cubes and 2 cups water, black beans, and tomatoes. Bring to a boil, reduce heat, and simmer 3 minutes or until mixture is thoroughly heated. Stir in spinach; cook 1 minute or until wilted.

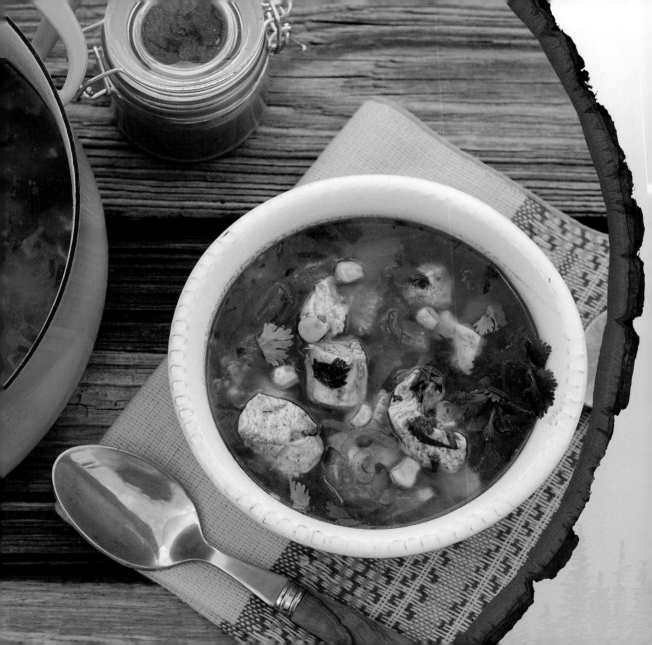

CROSS contamination—when bacteria from uncooked food is transferred to ready–to-eat foods—is riskier at campgrounds where you might not have adequate hot water and soap to clean cutting boards. One way to reduce the risk is to prep raw meat at home.

1 tablespoon extra-virgin olive oil

1 onion, quartered and sliced

2 garlic cloves, minced

2 teaspoons Mexican or Taco Seasoning Blend (page 229) or 1 teaspoon ground cumin and 1 teaspoon chili powder

2 (8-ounce) boneless, skinless chicken breasts, cut into pieces

4 cups chicken broth

2 medium tomatoes, seeded and diced

1 cup fresh or frozen corn kernels

2 tablespoons fresh lime juice

¼ cup chopped fresh cilantro

PREP AT HOME:

Slice onion and mince garlic; combine and store in an airtight container in the refrigerator.

Cut chicken into pieces; store in an airtight container in the refrigerator.

AT CAMPSITE:

Assemble a camp cookstove or prepare a charcoal or gas grill for medium-high heat.

Heat oil in a Dutch oven or soup pot over medium heat. Add onion and garlic; cook, stirring constantly, 3 minutes or until tender. Stir in seasoning; cook 1 minute. Add chicken; cook, stirring frequently, 3 to 5 minutes until almost done.

Stir in broth, tomatoes, and corn. Bring to a boil, reduce heat, and simmer 10 minutes.

Stir in lime juice and cilantro.

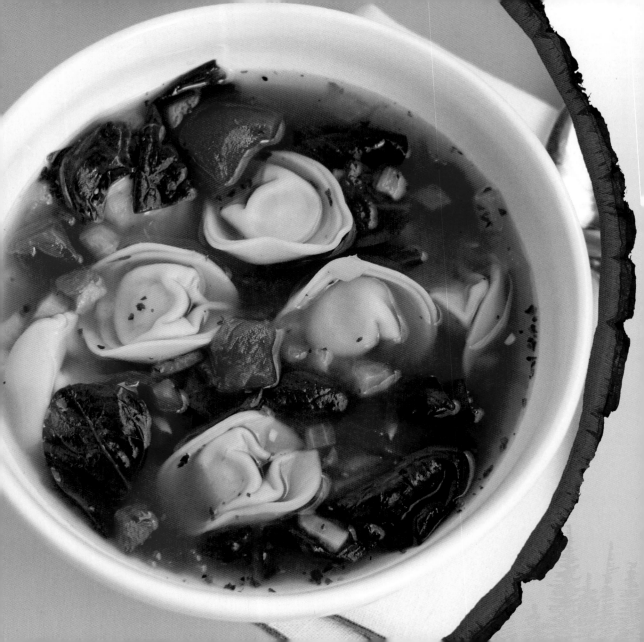

ADD EXTRA FLAVOR to this simple and healthy soup with Italian or basil-, garlic-, and oregano-flavored tomatoes.

2 teaspoons olive oil

½ onion

1 teaspoon freeze-dried Italian seasoning or mixed dried herbs (rosemary, thyme, and basil)

⅛ teaspoon crushed red pepper flakes

1 (32-ounce) carton vegetable broth

1 (14.5-ounce) can diced tomatoes, undrained

1 (9-ounce) package refrigerated mixed cheese tortellini

3 cups shredded [chopped] chard or kale

PREP AT HOME:

Chop onion. Store in an airtight container in the refrigerator.

Rinse chard or kale; dry completely. Remove thick stems, chop, and place in an airtight container.

AT CAMPSITE:

Assemble a camp cookstove. (Recipe may be made on a grill, if necessary.)

Heat oil in a Dutch oven or soup pot over medium-high heat. Add onion, seasoning, and red pepper flakes; cook 4 minutes or until onion is tender.

Stir in broth and tomatoes. Bring mixture to a boil; add tortellini. Reduce heat and gently boil, stirring occasionally, until tortellini is cooked, about 7 minutes. Stir in chard; cook until wilted, about 1 minute.

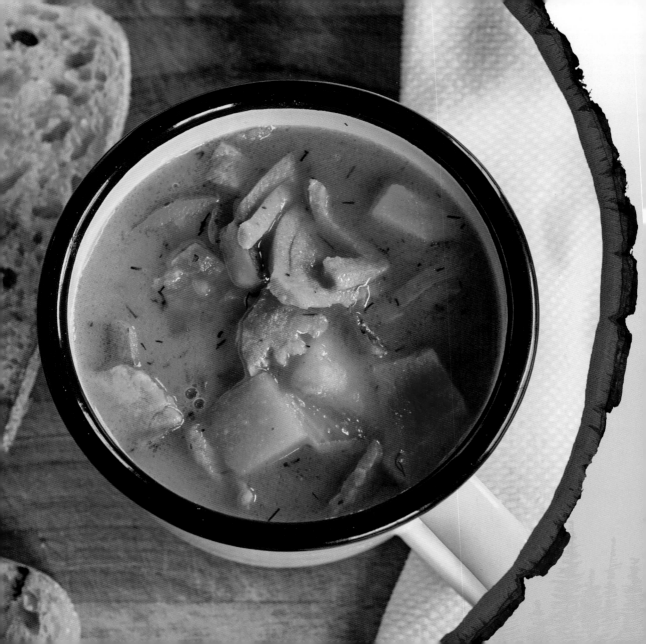

SALMON AND POTATO CHOWDER

UNCUT ONIONS and potatoes don't require cooler storage, and the potatoes will turn an unsightly brown if cut early, so don't prep at home.

- 3 cups chicken or fish broth or 3 chicken or fish bouillon cubes and 3 cups water
- 3 medium Yukon gold potatoes
- 3 tablespoons butter or oil
- 1 small onion, diced
- 2 tablespoons all-purpose flour
- 2 teaspoons Cajun Spice Mix (page 231), Mexican or Taco Seasoning Blend (page 229), or salt and pepper
- ¾ cups heavy cream or milk
- 4 ounces hot-smoked or cold-smoked salmon (or 6 ounces canned salmon, drained), cut into pieces
- ½ teaspoon chopped fresh or freeze-dried dill

AT CAMPSITE:

Assemble a camp cookstove.

Heat broth in a Dutch oven or soup pot over medium-high heat. Cut potatoes into pieces and add to broth (place in liquid right after cutting to prevent browning).

Melt butter in a large saucepan over medium heat. Add onion; cook 5 minutes or until tender. Stir in flour; cook 3 minutes, stirring constantly.

Stir in broth-potato mixture, seasoning blend, and cream. Bring to a simmer and cook 20 minutes, stirring occasionally, or until potatoes are cooked through. Add salmon; cook 1 minute or until thoroughly heated. Stir in dill.

Tip: Backpackers and other campers with minimal cooler space should use shelf-stable hot-smoked or canned salmon. Hot-smoked can be found on unrefrigerated shelves, is usually a thick cross-section of a fish fillet, and a pale pink color. Cold-smoked is found chilled, in thin, glossy slices and often with a very bright orange color. It's okay to use instant dry milk or just skip the cream if you don't have a cooler.

Sides & Salads

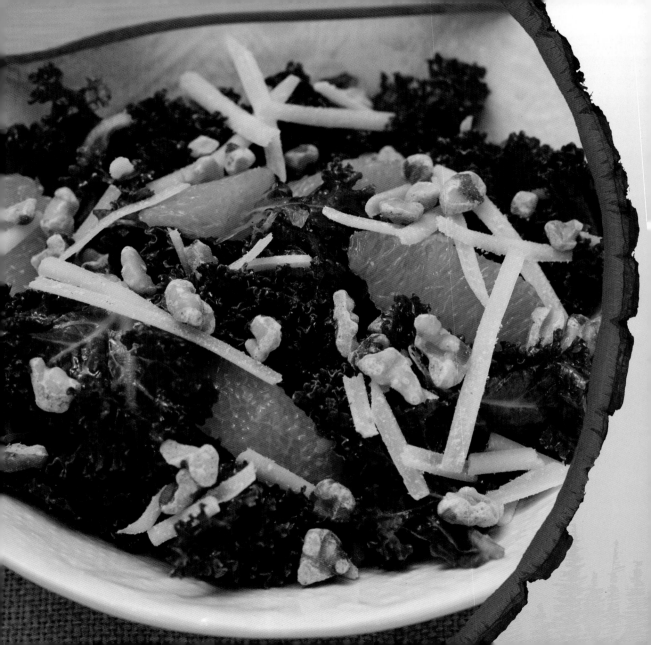

KALE SALAD WITH ORANGES AND WALNUTS

2 SERVINGS; WPS = 8 OZ.

THIS SALAD is ideal for backpackers because kale doesn't suffer from being packed tightly, unlike other easily bruised salad greens.

- 2 oranges, divided
- 1 tablespoon red wine vinegar
- 1 tablespoon extra-virgin olive oil
- Salt and pepper
- 4 ounces kale
- ¼ cup toasted walnut halves
- 1 ounce (2 tablespoons) freshly grated Parmesan cheese

PREP AT HOME:

Zest 1 orange to make ½ teaspoon; juice orange to make ¼ cup juice. Reserve remaining orange.

Combine zest, juice, vinegar, olive oil, and salt and pepper to taste in a small, sealed container.

Remove stems from kale, tear into pieces and place in a large plastic storage bag.

Toast walnuts; cool. Grate cheese. Combine and wrap in plastic until ready to serve.

AT CAMPSITE:

Stir prepared vinaigrette (zest and juice of 1 orange, vinegar, olive oil, salt, and pepper) into torn kale. Massage with hands so kale is completely coated and tender.

Peel remaining orange and cut into segments. Toss orange segments, walnuts, and cheese into salad mixture.

Variation: Substitute pine nuts for walnuts and crumbled feta cheese for Parmesan.

SIDES & SALADS 109

APPLE CRUNCH SALAD IN A JAR

FOR A HEARTIER salad meal, place ⅓ cup chopped or shredded cooked chicken or turkey in the bottom of each jar. Look for unsweetened vanilla yogurt or use plain. Sweetened vanilla yogurt is basically pudding and casts an unusual dessert vibe on the salad.

⅓ cup walnut halves, toasted

⅔ cup plain or unsweetened vanilla Greek yogurt

1 to 2 teaspoons honey

2 small apples

2 small stalks celery, chopped

2 tablespoons sweetened dried cranberries

2 cups chopped Romaine lettuce leaves

PREP AT HOME:

Preheat oven to 300°. Place walnuts on a sheet pan; bake 5 minutes or until very lightly toasted. Cool and coarsely chop; set aside.

Combine yogurt and honey in a medium bowl. Core apples and cut into cubes or coarsely chop. Stir into yogurt mixture. Chop celery and stir into mixture. Stir in cranberries and reserved toasted walnuts.

Divide apple mixture into 4 pint-size canning jars. Chop Romaine and add on top of apple mixture. Seal with lids and store in refrigerator until ready to serve (up to 1 day).

AT CAMPSITE:

Remove prepared salads (walnuts, yogurt mixed with honey, apples, celery, cranberries, and Romaine tossed together and placed in jars) from cooler. Just before eating, shake gently to combine ingredients.

GRILLED VEGGIE PANZANELLA SALAD

½ (16-ounce) loaf day-old crusty olive or Italian bread, cut into cubes

1 large zucchini, sliced in half lengthwise

1 red onion, cut into ¼-inch-thick slices

1 pint mixed red and yellow cherry tomatoes

¼ cup pitted Kalamata olives

½ cup red wine or Champagne vinegar

¼ cup extra-virgin olive oil

1 garlic clove

1 teaspoon Dijon mustard

Salt and pepper

¼ cup chopped fresh basil

PREP AT HOME:

Cut bread into 1 ½-inch cubes (large enough to prevent falling through grill grates). Place in a container. (It's even better if the bread cubes get stale.)

Dressing is best prepared at campsite but for ease may be made a day in advance. Combine vinegar, olive oil, garlic, mustard, and salt, and pepper to taste. Store in a container in the refrigerator.

AT CAMPSITE:

Prepare a gas or charcoal grill for medium-high heat or prepare a campfire.

Grill bread cubes 1 minute on each side or until toasted. Grill zucchini and onion 5 to 8 minutes on each side until tender. Cool slightly and cut into bite-size pieces.

Place bread, zucchini, onion, tomatoes, and olives in a large bowl, tossing to combine. Add prepared dressing (vinegar, olive oil, garlic, mustard, salt, and pepper) and basil, tossing to combine.

Backpackers: For shelf-stable packing, buy individual olive packs and substitute sun-dried tomato halves for fresh cherry tomatoes. Use 1 tablespoon freeze-dried basil, if necessary, in place of fresh basil leaves.

2 tablespoons plus 1 teaspoon Sweet-and-Spicy BBQ Blend (page 227), divided

1 pound lean flank steak, trimmed

⅓ cup extra-virgin olive oil

2 tablespoons red wine vinegar

½ cup (2 ounces) crumbled blue cheese

8 cups packed mixed salad greens

1 pint red and yellow cherry tomatoes, halved

PREP AT HOME:

Rub 2 tablespoons seasoning blend evenly on all sides of steak. Place in a plastic storage bag or airtight container. Refrigerate up to 2 days or freeze up to 3 months.

AT CAMPSITE:

Thaw prepared steak (coated with 2 tablespoons seasoning blend), if frozen.

Prepare a charcoal or gas grill for medium-high heat.

Combine remaining 1 teaspoon seasoning blend, oil, vinegar, and blue cheese in a small jar. Shake vigorously to blend; set dressing aside.

Place steak on greased grill rack. Grill 6 minutes on each side for medium or until desired degree of doneness. Let rest 5 to 10 minutes.

Arrange greens and tomatoes on a platter or 4 serving plates. Drizzle evenly with dressing. Cut steak diagonally across grain into thin slices and arrange over salad.

½ pound asparagus spears

2 (6-ounce) boneless, skinless chicken breasts

1 tablespoon olive oil

1 teaspoon Lemon-Pepper Blend (page 235), store-bought lemon-pepper seasoning, or salt and pepper

4 cups mixed salad greens

Lemon Yogurt Dressing (recipe below)

PREP AT HOME:

Wash and trim asparagus. Store in a plastic storage bag in the refrigerator.

Prepare Lemon Yogurt Dressing; store in an airtight container in the refrigerator.

AT CAMPSITE:

Prepare a charcoal or gas grill.

Brush asparagus and chicken with olive oil. Sprinkle with seasoning blend or salt and pepper.

Grill chicken 5 minutes on each side or until done. Grill asparagus, turning occasionally, 3 to 5 minutes or until tender.

Place lettuce on a serving platter. Top with chicken and asparagus; drizzle with dressing.

Lemon Yogurt Dressing

Stir together ½ cup plain Greek yogurt, ¼ cup olive oil, 2 tablespoons lemon juice, 1 minced garlic clove, ¾ teaspoon freeze-dried Italian seasoning, and salt and pepper to taste. Store in the refrigerator up to 3 days. Makes ¾ cup.

½ pound carrots

2 tablespoons extra-virgin olive oil

2 tablespoons fresh lemon juice

¼ cup chopped fresh cilantro

1 to 2 teaspoons Moroccan Seasoning Blend (page 233) or 1 teaspoon ground cumin

1 (10-ounce) pouch chickpeas or garbanzo beans, rinsed and drained

Salt and pepper

PREP AT HOME:

Wash and peel carrots. Slice carrots julienne style with a mandolin or julienne peeler, or coarsely grate. Place in an airtight container.

Stir together olive oil, lemon juice, cilantro, and seasoning; stir into carrots. Stir in chickpeas; sprinkle with salt and pepper. Cover and refrigerate 1 hour or up to 2 days before serving.

AT CAMPSITE:

Remove prepared salad (julienned carrots tossed with mixture of olive oil, lemon juice, herbs, seasoning, chickpeas, and salt and pepper to taste) from cooler and let come to room temperature (olive oil may solidify when chilled). Stir to blend dressing with carrots.

¼ cup butter, softened

2 tablespoons mayonnaise

1 teaspoon Mexican or Taco Seasoning Blend (page 229) or taco seasoning

1 tablespoon chopped fresh cilantro or 1 teaspoon freeze-dried cilantro

1 lime

4 fresh ears corn

¼ cup (1 ounce) grated Parmesan cheese or queso fresco

PREP AT HOME:

Prepare Mexican Seasoning Blend, if using.

Combine butter, mayonnaise, seasoning blend, and cilantro in a small bowl. Grate ½ lime into bowl. Juice lime into bowl; stir well until blended. Store in an airtight container in the refrigerator.

Pull back husks on corn, but do not remove. Remove and discard silks. Smooth husks back over corn; keep chilled.

AT CAMPSITE:

Prepare a charcoal or gas grill for medium-high heat. Remove prepared butter mixture (butter, mayonnaise, seasoning, cilantro, lime zest, and lime juice) from cooler and let soften at room temperature.

Grill corn, turning occasionally, 15 minutes or until tender. Peel back husks and tie together or discard. Spread butter mixture evenly over corn and sprinkle with cheese.

THE ZUCCHINI NOODLE craze is hitting hard, but it's a really great way to serve vegetables at camp because none of the ingredients are "cooler critical." In other words, they are not highly perishable and can simply be stored in a cool location instead of being iced down. You can make this very rich by adding an ounce or two of softened low-fat cream cheese (the lower fat version melts easier) just before adding zucchini and spinach.

2 medium zucchini squash

2 tablespoons butter or olive oil

1 large garlic clove

pinch crushed red pepper flakes

2 cups packed spinach

¼ cup grated fresh Parmesan cheese

1 teaspoon Lemon-Pepper Blend (page 235) or salt and pepper

PREP AT HOME:

Grate cheese; store in an airtight container in the refrigerator.

Prepare Lemon-Pepper Blend, if using.

AT CAMPSITE:

Assemble a camp cookstove.

Shave zucchini into ribbons using a vegetable peeler. Rotate periodically and stop when you get to the center with mostly seeds.

Melt butter or heat oil in a large skillet over medium heat. Add garlic and pepper flakes; cook 30 seconds to 1 minute or until fragrant. Add zucchini and spinach. Cook, tossing gently with tongs, for 2 to 3 minutes or until tender. Stir in cheese and sprinkle with Lemon-Pepper Blend.

GROUPING ASPARAGUS spears together on double skewers makes it easier to turn them on the grill...and you are less likely to lose a few between the grill grates! This works when the asparagus is fairly thick and the skewers thin. Thick wooden skewers will split young, thin asparagus. Generally, wooden skewers need to be soaked in water at least 30 minutes so they don't burn, but it's okay to skip that step when the food grills for only 5 minutes.

1 pound asparagus

8 (8-inch) wooden or metal skewers

2 tablespoons butter, softened, or olive oil

1 teaspoon Lemon-Pepper Blend (page 235) or salt and pepper

½ cup (2 ounces) shredded or shaved Parmesan cheese

PREP AT HOME:

Trim asparagus ends and shave cheese with a vegetable peeler. Store in separate airtight containers.

Prepare Lemon-Pepper Blend, if desired. Store in an airtight container.

AT CAMPSITE:

Prepare a charcoal or gas grill for medium-high heat.

Divide asparagus into 4 servings. Thread each portion of asparagus on 2 skewers about 2 or 3 inches apart. Grill asparagus rafts over medium-high heat 5 minutes on each side or until crisp-tender. Brush with butter, and sprinkle evenly with seasoning blend and cheese.

Variation: Substitute a desired amount of Lemon-Garlic Butter (page 237) for butter and seasoning blend.

Variation: Skewer the asparagus as directed, omitting Lemon-Pepper Blend, and brush with 2 teaspoons toasted sesame oil. When grilled, sprinkle with sesame seeds, and salt and pepper to taste.

THIS IS A GREAT way to use barely ripe tomatoes because very ripe ones will fall apart on the grill. Thick meaty tomatoes like Roma grill nicely; just slice in half.

4 medium heirloom tomatoes (firm, not overripe), sliced

2 tablespoons butter

1 garlic clove, minced

⅓ cup panko breadcrumbs

¼ cup grated Parmesan cheese

1 tablespoon fresh or dried chopped parsley

PREP AT HOME:

Portion ingredients. If desired, combine breadcrumbs, cheese, and parsley in a small container.

AT CAMPSITE:

Prepare a charcoal or gas grill for medium heat.

Slice tomatoes about ¼ inch thick. Grill 2 to 3 minutes on one side or until grill marks show. Transfer to a serving platter, grilled side up.

Melt butter in a skillet over medium heat; add garlic. Cook, stirring constantly, for 1 minute or until fragrant. Stir in breadcrumbs, Parmesan, and parsley. Cook, stirring constantly, until light golden brown. Sprinkle over tomatoes, and serve warm.

GRILLED MEDITERRANEAN CAULIFLOWER

THE GOAL IS to grill wide planks of cauliflower, but pieces on the sides tend to come off in florets. Just cut those in half and, if large enough, grill as usual. Small pieces that would fall through grill grates should be placed on a piece of aluminum foil. Any seasoning blend will work, or go simple with salt and pepper.

1 head cauliflower

2 tablespoons extra-virgin olive oil

2 tablespoons Moroccan Seasoning Blend (page 233)

3 tablespoons Lemon-Garlic Butter (page 237), cut into pieces, or 2 lemon wedges

PREP AT HOME:

Prepare Moroccan Seasoning Blend and store in an airtight container.

Prepare Lemon-Garlic Butter and store in the refrigerator or freezer.

AT CAMPSITE:

Prepare gas or charcoal grill for medium-high heat. Cut cauliflower into ½- to ¾-inch planks.

Brush cauliflower on both sides with oil and sprinkle both sides with seasoning blend.

Grill cauliflower 5 minutes on each side until tender. (Place small pieces of cauliflower that would fall through the grate on aluminum foil and grill until tender.)

Transfer to a platter, and dot cauliflower with small pieces of Lemon-Garlic Butter, or drizzle with additional oil and the juice of 2 lemon wedges.

SUCCOTASH isn't usually a vegetarian side, but you won't miss the bacon too much because the vegetables have a subtle smoky flavor from the grill. Bacon fans can easily stir in a couple of cooked and crumbled slices!

1 cup frozen and thawed baby lima beans or small edamame

2 ears fresh corn

1 small red onion

1 red bell pepper

2 small zucchini squash

2 strips bacon (optional)

¼ cup Lemon-Garlic Butter (page 237)

Salt and pepper

PREP AT HOME:

Portion lima beans or shuck edamame, if necessary.

Shuck corn, removing silks.

Cut onion into wedges. Cut bell pepper in half and remove seeds. Cut ends from zucchini and slice in half. Place cut vegetables in a large plastic storage bag and refrigerate.

Prepare and portion Lemon-Garlic Butter.

AT CAMPSITE:

Prepare a gas or charcoal grill for medium heat. Thaw lima beans, if necessary.

Grill corn, onion, and bell pepper over medium heat for 8 to 10 minutes, turning occasionally. Grill zucchini 5 to 7 minutes, turning once, until tender. Cook bacon, if using, in a skillet over medium heat until crisp.

Cut kernels from corn and place in a large bowl. Cut onion, bell pepper, and zucchini into bite-size pieces or strips. Stir Lemon-Garlic Butter into hot vegetables, stirring until butter melts. Stir in lima beans. Season with salt and pepper to taste. Crumble bacon, if using, and sprinkle on top.

PUT THESE ON your keeper list when your vegetarian friends come to your cookout. You may need to make more as a side dish because the carnivores will get jealous!

2 extra-large Portobello mushrooms, stems removed

1 tablespoon extra-virgin olive oil

2 (¼-inch-thick) large tomato slices

2 (¼-inch-thick) fresh mozzarella slices

4 teaspoons refrigerated pesto

2 teaspoons balsamic glaze*

PREP AT HOME:

*If not using store-bought balsamic glaze, combine 1 cup balsamic vinegar and ¼ cup sugar in a saucepan over medium heat. Bring to a boil, reduce heat, and simmer vigorously until mixture is thick and syrupy. Cool to room temperature, then store in an airtight container in the refrigerator. Serve extra glaze over vegetables, grilled meats, and salads.

AT CAMPSITE:

Prepare a charcoal or gas grill for medium-high heat.

Brush mushrooms evenly with olive oil. Grill, cut side down, 3 to 4 minutes. Turn over and grill 3 to 4 more minutes until tender. Drain any liquid that accumulates in cap.

Place 1 tomato slice and 1 slice mozzarella in stem side of mushroom. Place mushrooms on grill, cover with lid or aluminum foil, and grill 2 minutes or until cheese begins to melt and mushroom is tender. Drizzle each with 2 teaspoons pesto and 1 teaspoon balsamic glaze.

6 tablespoons butter, divided

½ cup panko breadcrumbs

¼ teaspoon garlic salt

¼ cup freshly grated Parmesan cheese

8 ounces 3-minute quick-cooking elbow macaroni

3 tablespoons all-purpose flour

¼ teaspoon cayenne pepper

½ teaspoon salt or garlic salt

2 cups milk

1 (8-ounce) package sharp Cheddar cheese, grated

PREP AT HOME:

Combine flour, cayenne, and salt in a plastic storage bag.

Grate Cheddar cheese; store in the refrigerator.

AT CAMPSITE:

Assemble a camp cookstove.

Melt 2 tablespoons butter in a 10- to 12-inch skillet over medium heat. Add breadcrumbs and garlic salt. Cook, stirring constantly, 5 minutes or until breadcrumbs are toasted and crunchy. Remove from heat and stir in Parmesan. Transfer to a plate and set aside.

Cook pasta in boiling water to cover according to package directions, about 3 minutes. Drain, and set aside.

Melt remaining 4 tablespoons butter in skillet, swirling to coat bottom of pan. Add flour, cayenne, and salt, stirring until blended. Cook 1 to 2 minutes, stirring constantly. Stir in milk; cook, stirring frequently, 5 minutes or until thickened and bubbly. Add cheese, stirring until well blended.

Stir pasta into cheese mixture. Sprinkle with breadcrumb mixture.

1 cup uncooked orzo

2 small zucchini squash, halved and sliced

1 cup cherry or plum tomatoes, halved

1 ½ to 2 teaspoons Moroccan Seasoning Blend (page 233)

2 teaspoons chopped fresh mint

PREP AT HOME:

Prepare Moroccan Seasoning Blend; store in an airtight container.

AT CAMPSITE:

Assemble a camp cookstove. Prepare a charcoal or gas grill for medium-high heat.

Cook orzo in boiling water to cover about 8 minutes or until tender. Drain; transfer to a bowl. Cover to keep warm.

Slice zucchini in half lengthwise. Grill over well-greased grill grates 3 minutes on each side. Cut into bite-size pieces. Stir into orzo. Stir in tomatoes, seasoning blend, and mint.

Tip: If you don't have a grill, heat 1 tablespoon oil in a nonstick skillet over medium heat. Add sliced zucchini. Cook, stirring frequently, 3 to 5 minutes or until tender. Stir in tomatoes; cook, stirring occasionally, until heated through.

1 extra-large vegetable bouillon cube and 1 ¼ cups water or 1 ¼ cups vegetable broth

⅓ cup soy sauce

2 tablespoons light brown sugar

1 teaspoon chili-garlic paste or ¼ teaspoon crushed red pepper

1 tablespoon cornstarch

1 tablespoon vegetable oil

4 cups chopped vegetables, such as bell pepper, yellow squash, shredded carrots, asparagus, green beans, mushrooms, cabbage

4 cups leftover cooked white or brown rice

PREP AT HOME:

Chop vegetables; store in an airtight container in the refrigerator.

Cook rice; store in an airtight container in the freezer up to 3 months.

AT CAMPSITE:

Assemble a camp cookstove or prepare a charcoal or gas grill for medium-high heat.

Combine bouillon cube and 1 ¼ cups water in a 2-cup measuring cup. Add soy sauce, brown sugar, chili-garlic paste, and cornstarch, stirring or whisking until well blended.

Heat a large nonstick skillet over medium-high heat. Add 1 tablespoon oil; swirl oil to coat. Add mixed vegetables; stir-fry 1 to 2 minutes. Add rice; cook 2 to 3 minutes or until thoroughly heated.

Stir in broth mixture; cook 2 to 3 minutes or until thickened.

WILD MUSHROOM-AND-SPINACH RISOTTO

4 cups vegetable or chicken broth or 4 bouillon cubes and 4 cups water

1 tablespoon olive oil

8 ounces wild or button mushrooms, chopped

1 cup Arborio rice

2 garlic cloves, minced

1 (5-ounce) package fresh spinach, chopped

½ cup (2 ounces) freshly grated Parmesan cheese

Salt and pepper

PREP AT HOME:

Chop mushrooms and spinach; store in separate airtight containers in the refrigerator.

Grate cheese; store in an airtight container in the refrigerator.

AT CAMPSITE:

Prepare a gas or charcoal grill for medium to medium-high heat. Or assemble a camp cookstove.

If using bouillon cubes, heat 4 cups water in a saucepan; stir in bouillon. Keep warm.

Heat oil in a saucepan over medium heat. Add mushrooms and cook, stirring frequently, 4 to 5 minutes or until tender. Stir in rice and garlic. Cook 2 minutes, stirring constantly.

Add broth, 1 cup at a time, stirring constantly until each portion of water is absorbed before adding the next. Continue until rice is tender.

Add spinach and cheese, stirring until well blended and spinach wilts. Season with salt and pepper to taste.

TAKE THIS RECIPE into main–dish territory by stirring in shredded chicken or sliced steak and some chopped cooked vegetables after the rice cooks. A dollop of sriracha sauce adds a punch of flavor.

1 bouillon cube with 1 cup water or 1 cup vegetable or chicken broth

1 (14-ounce) can regular or light coconut milk

1 ½ cups long-grain jasmine or basmati rice

1 tablespoon chopped fresh or 1 teaspoon dried cilantro

AT CAMPSITE:

Reconstitute bouillon cube in 1 cup water, if necessary.

Combine broth and coconut milk in a saucepan. Bring to a boil; stir in rice. Reduce heat and cover. Cook 15 minutes or until liquid is absorbed and rice is tender. Remove from heat and let stand 5 minutes. Stir in cilantro.

1 teaspoon granules or 1 cube vegetable or chicken bouillon

1 cup plain or whole wheat couscous

1 cup mixed dried fruit (cranberries, chopped apricots, cherries, figs, and/or chopped dates)

¼ to ⅓ cup toasted pine nuts

1 to 2 teaspoons Moroccan Seasoning Blend (page 233) or ½ teaspoon ground cumin and ¼ teaspoon salt

1 tablespoon olive oil

PREP AT HOME:

Combine couscous and dried fruit in a plastic storage bag. If using bouillon granules, stir into couscous mixture.

Toast pine nuts; cool and place in an airtight container.

AT CAMPSITE:

Bring 1 ½ cups water to boil with bouillon, stirring until well blended. Stir in couscous and dried fruit. Remove from heat. Cover, and let stand 5 minutes.

Stir in pine nuts, Moroccan Seasoning Blend, and olive oil.

3 chicken or vegetable bouillon cubes

½ teaspoon chopped fresh rosemary or freeze-dried Italian seasoning

1 cup instant polenta or grits

1 tablespoon grated fresh Parmesan cheese

AT CAMPSITE:

Assemble a camp cookstove.

Bring 3 cups water and bouillon to a boil in a medium saucepan over medium-high heat. Whisk in seasoning and polenta. Reduce heat to low, and cook 1 minute or until polenta is tender. Stir in Parmesan.

¼ cup olive oil

2 large garlic cloves, minced

1 tablespoon chopped fresh rosemary or herb mix

1 pound large Yukon Gold or russet potatoes (about 2-3)

Salt and pepper

PREP AT HOME:

Combine oil, garlic, and herbs in a container.

Don't slice potatoes—they will turn brown if cut early.

AT CAMPSITE:

Prepare a gas or charcoal grill for medium-high heat.

Pour prepared oil mixture (olive oil, garlic, and herbs) into a serving bowl. Cut potatoes into 8 wedges each. Add to oil mixture, tossing to coat. For more flavor, marinate potatoes 15 to 30 minutes.

Drain potatoes, reserving oil. Grill potatoes for 15 minutes, turning occasionally, until golden brown and tender. Transfer potatoes to a bowl, tossing to coat with remaining oil. Season with salt and pepper to taste.

TO MAKE this dish at home, assemble as directed in a Dutch oven or greased 13x9–inch baking dish. Bake at 375° for 45 minutes to 1 hour or until sauce is bubbly and potatoes are tender.

2 tablespoons butter

2 pounds red or Yukon gold potatoes, thinly sliced

1 yellow onion, halved and sliced (optional)

1 tablespoon chopped fresh rosemary

Salt and pepper

4 ounces (½ cup) shredded Cheddar cheese

2 ounces (½ cup) grated Parmesan cheese

1 cup half-and-half

PREP AT HOME:

Wash and dry potatoes; do not slice potatoes—they will turn brown. Slice onion, if desired.

Grate cheeses and combine in a plastic storage bag or container.

AT CAMPSITE:

Prepare a charcoal fire, starting with 23 to 25 briquettes (see Dutch-Oven Cooking, page 10).

Generously butter a 10-quart cast-iron Dutch oven with 2 tablespoons butter. Layer half of potato, onion, rosemary, and salt and pepper to taste in bottom of pan. Top with half of cheeses. Repeat layer with remaining potato, onion, seasonings, and cheese. Pour half-and-half over mixture.

Place lid on Dutch oven. Place over 7 to 8 coals, and top with 16 to 18 coals on lid. Cook 45 minutes to 1 hour or until sauce is bubbly and potatoes are tender. Rotate oven every 15 to 20 minutes for even cooking.

1 medium sweet potato, peeled and cubed

2 heaping teaspoons dried cranberries

2 heaping teaspoons chopped pecans

2 teaspoons pure maple syrup

4 teaspoons butter

Salt and pepper

PREP AT HOME:

If desired, assemble packets ahead and refrigerate up to 2 days.

AT CAMPSITE:

Prepare a charcoal or gas grill for medium heat. Or prepare a wood campfire. Cut 2 (12-inch-long) pieces of heavy-duty aluminum foil.

Cube sweet potatoes and divide evenly between the 2 pieces of foil. Sprinkle cranberries and pecans over potatoes. Drizzle each with 1 teaspoon maple syrup. Cut butter into small pieces and sprinkle evenly over potatoes. Sprinkle with salt and pepper to taste.

Bring opposite ends of foil together, folding edges together. Fold remaining ends to seal packets. Grill over medium heat for 15 minutes, turning every 5 minutes. (Don't be tempted to use high heat to cook packets faster. The maple syrup and natural sugars in the sweet potatoes will burn.)

Open foil carefully to let steam escape.

LOADED WITH FLAVOR, this bean side dish can be served as a main dish too. Feel free to substitute other types of beans, such as dark or light kidney beans, cannellini beans, or Great Northern beans.

1 tablespoon olive oil

12 ounces smoked kielbasa sausage, sliced diagonally

1 large onion, finely chopped

1 green bell pepper, finely chopped

4 garlic cloves, minced

2 apples, peeled, cored, and chopped

1 cup Smoky Molasses BBQ Sauce (page 245)

1 cup dark ale or beer

1 (15-ounce) can black beans

2 (15-ounce) cans pinto beans

PREP AT HOME:

Slice sausage and chop onion, bell pepper, and garlic; place in a plastic storage container in the refrigerator. (Apples are best cut at camp because they brown.)

AT CAMPSITE:

Prepare a charcoal or gas grill or assemble a camp cookstove.

Heat oil in a large Dutch oven or deep skillet over medium-high heat. Add sausage, onion, bell pepper, and garlic. Cook, stirring occasionally, 8 minutes or until tender. Add apple; cook 2 minutes or until tender.

Stir in Smoky Molasses BBQ Sauce and beer. Drain beans and stir into vegetable mixture. (Rinsing and draining beans is preferred to remove some of the "canned" taste; however, if this is too water-wasteful, just drain well.)

Cook 20 minutes or until hot and bubbly.

Meat & Seafood

PEOPLE LOVE TO create their own gourmet pizzas. For fun, you can ask your fellow campers to bring specific favorite ingredients. You can also use Skillet Flatbread (page 43) for a base instead of commercial pizza dough.

1 pound refrigerated or frozen pizza dough

Optional toppings: grilled chicken, grilled zucchini, grilled sausages, grilled peppers, pepperoni, halved cherry tomatoes, halved kalamata olives, chopped cooked bacon

½ to ¾ cup marinara, alfredo, or pesto sauce

CHEESES: mozzarella cheese, goat cheese, Parmesan cheese

HERBS: sliced fresh basil, chopped fresh thyme, or chopped chives

PREP AT HOME:

Slice vegetables and other toppings. Grate cheese. Store in an airtight container in the refrigerator.

AT CAMPSITE:

Prepare a gas or charcoal grill. Let dough rest on cutting board until room temperature (it's easier to roll if not cold).

Grill vegetable or meat toppings, if desired. Cut into bite-size pieces.

Cut dough into 4 pieces. Press or roll dough into thin circles or free-form shapes.

Place dough pieces on greased grill grate and grill 3 minutes.

Remove from grill and place, marked side up, on a work surface. Spread pizza or alfredo sauce on grilled side of dough. Add toppings and cheese. Return pizza to grill; grill 4 to 5 minutes until cooked. Sprinkle with herbs, if desired.

GRILLED BUFFALO WINGS

3 pounds chicken drumettes and/or wings

1 ½ teaspoons garlic salt or 1 teaspoon garlic powder and ½ teaspoon salt

4 tablespoons butter

⅓ cup hot sauce

1 tablespoon apple cider vinegar

1 tablespoon light brown sugar

Blue Cheese Dressing (recipe below)

Carrot and celery sticks

PREP AT HOME:

Separate chicken drumettes from wings, if necessary. Sprinkle evenly with garlic salt. Store in a large plastic storage bag or airtight container. Refrigerate at least 6 hours to overnight.

AT CAMPSITE:

Prepare a charcoal or gas grill for medium-high heat. Grease grill grates thoroughly.

Grill wings, covered with grill lid or foil, turning occasionally, for 20 to 25 minutes until golden brown with crisp skin.

Meanwhile, melt butter in a saucepan. Stir in hot sauce, vinegar, and brown sugar. Set aside. Prepare Blue Cheese Dressing.

Remove from grill and toss in hot sauce mixture. Serve with dressing and carrot and celery sticks.

Blue Cheese Dressing

Stir together ¼ cup mayonnaise, ¼ cup buttermilk, 2 teaspoons apple cider or white vinegar, ½ cup crumbled blue cheese, and salt and pepper to taste in a bowl, whisking until well blended. Makes about ¾ cup.

¾ cup Basic Meat-and-Veggie Marinade (page 241)

¼ cup chopped fresh cilantro

¼ cup chopped fresh parsley

4 boneless, skinless chicken breasts

PREP AT HOME:

Prepare marinade; store in an airtight container in the refrigerator.

Trim chicken of excess fat. Pound chicken to equal thickness (to avoid burning thin parts while thicker areas cook).

AT CAMPSITE:

Prepare a charcoal or gas grill for medium-high heat.

Combine marinade with chopped fresh herbs in a large plastic storage bag or container. Set aside ⅓ cup in a small container. Add chicken to bag or bowl, tossing to coat. Let marinate 30 minutes (no longer or lemon juice may cause an unpleasant texture).

Remove chicken from marinade; grill 5 minutes on each side or until done. Place on a platter and drizzle with reserved herb mixture.

4 chicken bouillon cubes or 4 cups chicken broth

2 tablespoons olive oil

1 small onion, chopped

2 stalks celery, chopped

2 carrots, chopped

1 ½ teaspoons poultry seasoning

2 cups chopped cooked chicken

Salt and pepper

1 ½ cups Basic Baking Mix (page 239)

½ cup milk

PREP AT HOME:

Chop onion, celery, and carrots and place in a bag or container. Stir in poultry seasoning. Refrigerate until ready to cook.

Prepare Basic Baking Mix.

Cook chicken (about 2 breasts) and shred or chop.

AT CAMPSITE:

Prepare a charcoal or gas grill or assemble a camp cookstove.

Heat oil in a 10- to 12-quart Dutch oven over medium-high heat. Add onion, celery, carrots, and poultry seasoning; cook 3 to 5 minutes, stirring constantly, until vegetables are tender. Stir in broth. Simmer 5 minutes. Stir in chicken; cook 3 to 5 minutes until heated through. Add salt and pepper to taste.

Meanwhile, combine baking mix and milk in a bowl. Drop tablespoons of dumpling batter into hot broth. Cover and reduce heat to medium, or move to a slightly cooler area of grill. Simmer 10 minutes until dumplings are cooked.

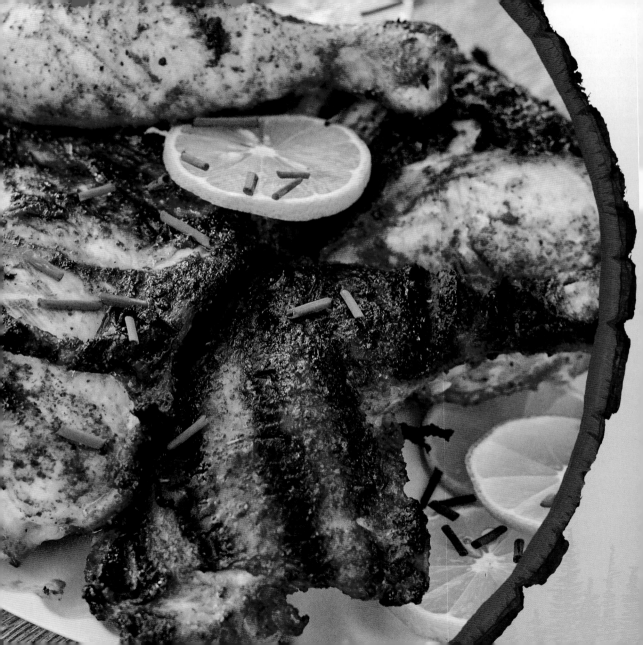

2 tablespoons sweetened (not sugar-free) lemonade powdered drink mix

3 tablespoons Sweet-and-Spicy BBQ Blend (page 227), Mexican or Taco Seasoning Blend (page 229) , or taco seasoning blend

4 pounds bone-in, skin-on chicken quarters

GARNISH: chopped chives

PREP AT HOME:

Combine lemonade mix and spice blend in a large plastic storage bag.

Add chicken to bag, tossing to coat with seasoning. Seal and store in refrigerator up to 24 hours.

AT CAMPSITE:

Prepare a gas or charcoal grill for indirect heat (see page 9).

Grill prepared chicken (tossed with lemonade mix and seasoning to coat and refrigerated for 24 hours), skin side down, over medium-high heat for 5 minutes. Turn chicken over and move to unheated side of grill. Grill, bone side down and covered with lid or foil, 30 minutes or until done. Chicken should register 170° at thickest portion. Garnish, if desired.

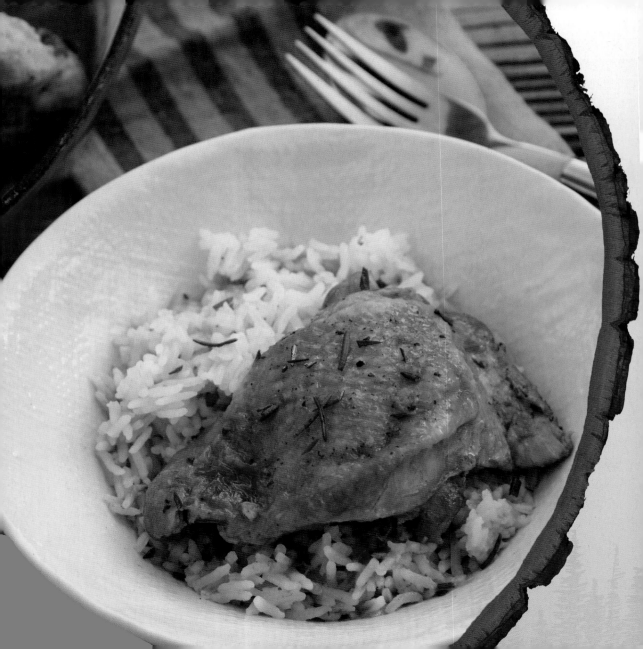

1 tablespoon olive oil

1 (3 ½- to 4-pound) whole chicken*

Salt and pepper

1 chicken bouillon cube (or 1 cup broth)

1 orange

¼ cup balsamic vinegar

¼ teaspoon hot pepper flakes

2 teaspoons chopped fresh rosemary

PREP AT HOME:

Cut chicken into 8 pieces. If breasts are large, cut each in half so pieces are approximately the same size. Place in an extra-large plastic storage bag.

Juice 1 orange (about ½ cup). Combine with balsamic vinegar, pepper flakes, and rosemary. Store in an airtight container until ready to use.

If desired, stir in 1 cup broth or reconstitute bouillon at camp.

AT CAMPSITE:

Assemble a camp cookstove. Heat oil in a 12-inch cast-iron skillet over medium-high heat.

Sprinkle chicken with salt and pepper to taste. Cook chicken 5 minutes, turning occasionally, until brown on all sides.

Reconstitute bouillon in 1 cup water, if necessary. Combine broth and juice mixture (juice of 1 orange, balsamic vinegar, pepper flakes, and rosemary), and pour over chicken.

Cover and simmer over medium-low heat for 30 minutes or until chicken is tender.

* Substitute 6 skin-on, bone-in chicken thighs or 4 skin on, bone-in breasts

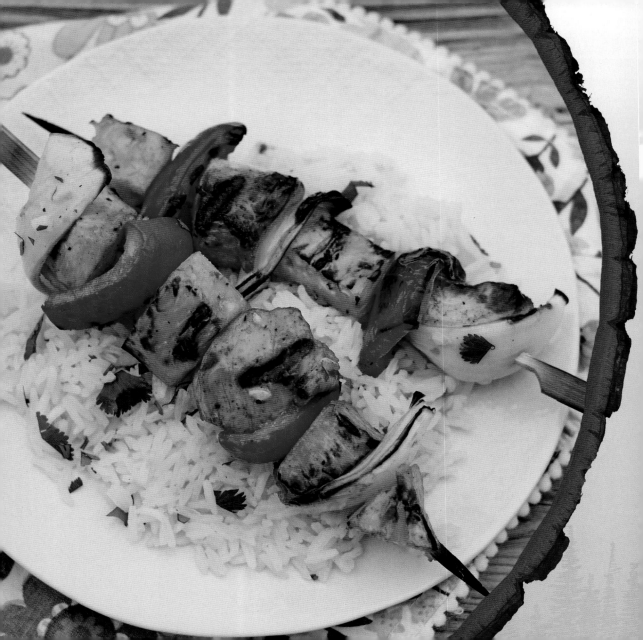

MAKE IT A MEAL with hot Coconut Rice (page 143). Pineapples contain enzymes that can cause the texture of meat to turn mushy. The onions and peppers can be marinated with the chicken but not the pineapple.

¼ cup orange juice or 1 orange, juiced

3 tablespoons soy sauce

2 teaspoons Jerk seasoning blend

1 pound boneless, skinless chicken thighs or breasts, cut into 2-inch pieces

1 onion, cut into pieces

2 red bell peppers, cut into pieces

½ pineapple, cubed

¼ cup Lemon-Garlic Butter (page 237), melted

PREP AT HOME:

Cut onion, bell pepper, and pineapple into 1 ½ to 2-inch pieces; store in an airtight container in the refrigerator.

Cut chicken into bite-size pieces. Store in an airtight container in the refrigerator.

Prepare Lemon-Garlic butter; portion and freeze until ready to pack in cooler.

Soak wooden skewers in water for 1 hour. Drain, leaving skewers very damp, and wrap in foil.

AT CAMPSITE:

Combine orange juice, soy sauce, and seasoning in a shallow pan or plastic storage bag. Add chicken, tossing to coat. Marinate in refrigerator or cooler 2 to 6 hours.

Prepare a gas or charcoal grill. Soak skewers in water at least 30 minutes, if not soaked ahead.

Drain chicken, discarding marinade. Thread chicken, onion, bell pepper, and pineapple on skewers.

Grill on greased grill rack 10 minutes, turning occasionally and basting with butter.

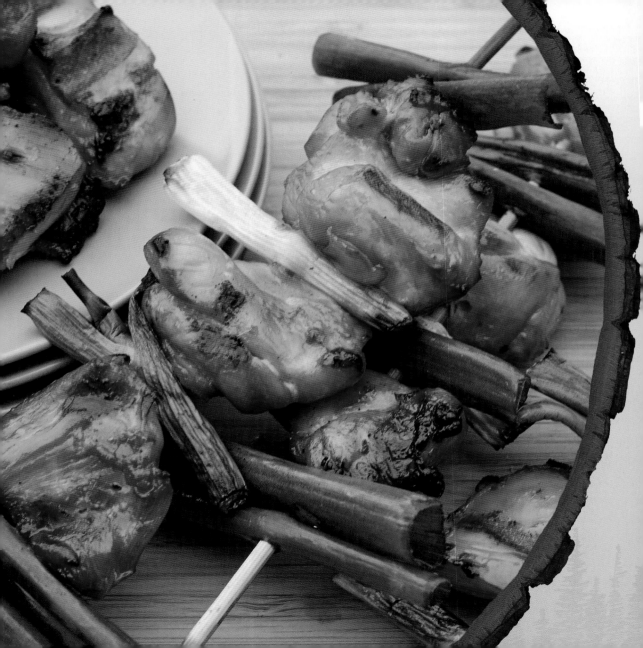

CHICKEN YAKITORI KEBABS

½ cup soy sauce

¼ cup sake or mirin

2 tablespoons dark or light brown sugar

1 teaspoon grated fresh ginger

1 ¾ pounds boneless chicken thighs or breasts

6 green onions

PREP AT HOME:

Combine soy sauce, sake, brown sugar, and ginger in a plastic storage bag or small container.

Cut chicken into 1-inch pieces. Place chicken into a separate plastic storage bag.

Soak wooden skewers in water 1 hour. Drain, leaving skewers very damp, and wrap in foil.

AT CAMPSITE:

Pour marinade (soy sauce, sake, brown sugar, and ginger) into storage bag with chicken pieces; seal and marinate 30 minutes to 4 hours.

Prepare a gas or charcoal grill for medium-high heat.

Slice onions into 2-inch pieces. Thread chicken and green onion on skewers. Grill 6 to 8 minutes, turning occasionally, until chicken is done.

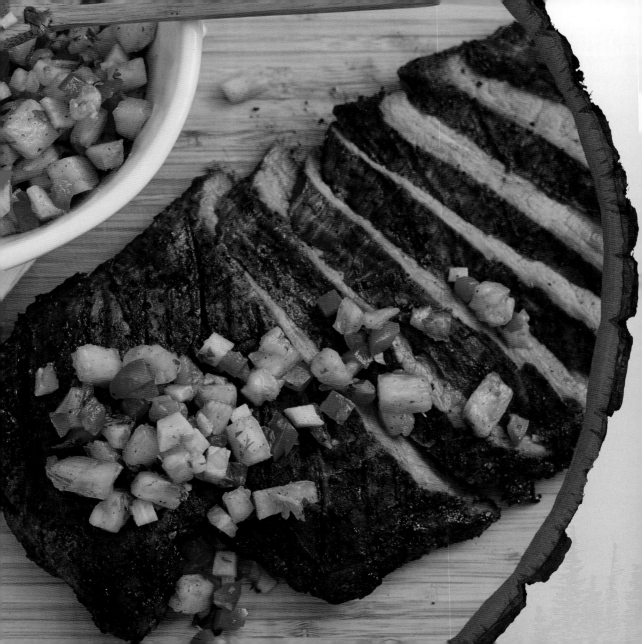

ADDING ESPRESSO and cocoa powder to the BBQ seasoning blend adds a deep earthy flavor to the steak. The lively Pineapple Salsa adds a refreshing accent.

3 tablespoons Sweet-and-Spicy BBQ Blend (page 227)

1 teaspoon unsweetened cocoa powder

½ teaspoon espresso powder

1 ½ pounds flank steak, trimmed

Pineapple Salsa (page 59)

PREP AT HOME:

Prepare Sweet-and-Spicy BBQ Blend. Combine BBQ seasoning, cocoa powder, and espresso powder. Rub over all sides of steak. Place in a plastic storage bag; seal and store in the refrigerator up to 3 days.

Pineapple Salsa can be prepared several hours to one day ahead. Refrigerate until ready to serve.

AT CAMPSITE:

Prepare a charcoal or gas grill for high heat. Remove prepared steak (rubbed with Sweet-and-Spicy BBQ Blend, cocoa powder, and espresso powder) from cooler and let stand at room temperature for 15 minutes. Prepare salsa, if necessary, and set aside.

Grill flank steak over high heat 6 minutes on each side for medium rare or until desired degree of doneness. Let rest 10 minutes before slicing. Serve with Pineapple Salsa.

CAMPFIRE MEAT LOAF IN FOIL POUCHES

4 SERVINGS; WPS = 4.5 OZ.

1 pound 80% to 95% lean ground beef

1 ¼ cups finely chopped onion

¾ cup panko breadcrumbs or crushed saltine crackers

¼ cup Smoky Molasses BBQ Sauce (page 245) or purchased barbecue sauce

1 large egg, beaten

PREP AT HOME:

Prepare Smoky Molasses BBQ Sauce, if using. Store in a sealed jar in the refrigerator.

If desired, assemble meat loaves in aluminum foil packages and seal. Refrigerate up to 2 days before cooking.

AT CAMPSITE:

Prepare a charcoal or gas grill for medium-high heat.

Tear off 4 (18-inch) pieces of heavy-duty aluminum foil.

Combine beef, onion, breadcrumbs, sauce, and egg in a large bowl. Divide mixture into 4 portions; place 1 portion in center of each foil piece. Pat each portion into a 1-inch-high loaf. Fold edges of foil together; crimp in center and edges to form a packet for each loaf.

Grill 10 minutes on each side and let rest 5 minutes. Open foil carefully to let steam escape. Serve with additional sauce, if desired.

1 (16-ounce) container ricotta cheese

1 large egg

Salt and pepper

8 ounces (2 cups) shredded mozzarella cheese

3 ounces (¾ cup) grated Parmesan cheese

1 pound uncooked Italian-seasoned sausage, casings removed

1 pound lean ground beef or ground venison

1 (25-ounce) jar store-bought seasoned marinara sauce

6 to 9 oven-ready lasagna noodles

PREP AT HOME:

Shred mozzarella and grate Parmesan. Store together in a plastic storage bag.

For faster prep at campsite, pre-cook sausage and ground beef. Drain, cool, and store in an airtight container.

AT CAMPSITE:

Prepare a charcoal campfire. Combine ricotta and egg in a bowl; stir in salt and pepper to taste. Cover and set aside. In a separate bowl, stir together mozzarella and Parmesan cheeses; set aside.

Heat a (10- to 12-inch) cast-iron camping Dutch oven to medium or medium-high heat. Add meat and cook 5 minutes or until meat is browned and crumbled. Drain.

Combine meat and marinara sauce in a bowl. Spread ⅓ meat sauce in bottom of Dutch oven. Arrange half of noodles over sauce, breaking in pieces to fit in pot. (Try not to overlap noodles; they need to be in contact with wet ingredients to soften.) Top with ½ ricotta mixture and ⅓ cheese mixture. Repeat with ⅓ sauce, remaining ½ noodles, remaining ½ ricotta mixture, and ⅓ cheese mixture. Top with remaining ⅓ meat sauce and ⅓ cheeses.

Cover and place Dutch oven over 8 briquettes. Place 16-17 briquettes on lid. Bake (at about 375°) for 40 minutes or until noodles are tender and lasagna is bubbly and browned. Remember to check and add briquettes every 20 minutes to maintain temperature.

Herbed Polenta (page 147)

2 teaspoons olive oil

14 ounces smoked sausage, halved and sliced

2 yellow, red, or orange bell peppers, thinly sliced

1 (8-ounce) package cremini mushrooms, sliced

1 small onion, halved and sliced

2 teaspoons chopped fresh rosemary or thyme (or 1 teaspoon each)

PREP AT HOME:

Slice sausages and store in an airtight container in the refrigerator.

Slice bell pepper, mushrooms, and onion. Store in an airtight container in the refrigerator.

AT CAMPSITE:

Assemble a camp cookstove. Prepare polenta; cover and keep warm.

Heat oil in a cast-iron or large heavy nonstick skillet over medium heat. Add sausage and cook 5 minutes, stirring occasionally, until browned on all sides. Transfer to a plate and set aside.

Add bell pepper, mushrooms, and onion to skillet. Cook 5 minutes, stirring often, until just slightly wilted. Stir in ⅓ cup water, herbs, and cooked sausage. Cover, and cook over low heat 5 minutes or until vegetables are tender.

Spoon polenta onto a serving platter or individual plates. Top with sausage mixture.

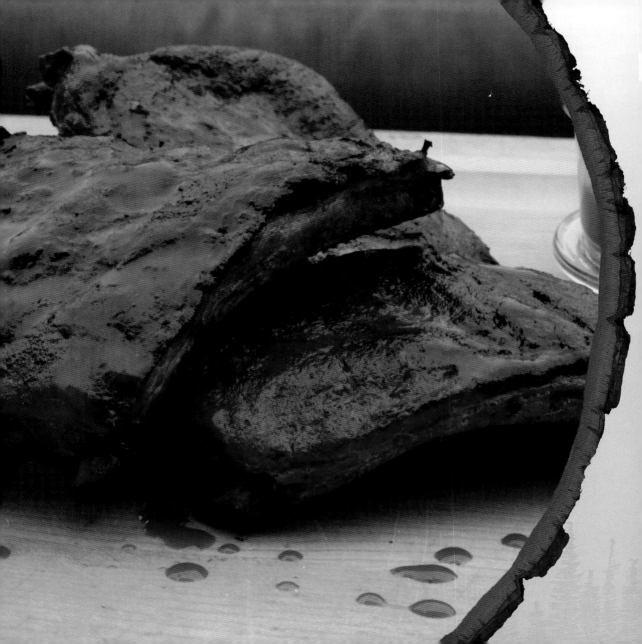

THIS IS POSSIBLY one of the easiest ways to make tasty and tender ribs. You can substitute other types of ribs, but baby backs are smaller and cook faster—important if you are rationing fuel. Ribs are often cooked with indirect heat; wrapping in foil protects the meat from too much char in a similar way. To achieve the beloved light caramelized char on the outside, remove from foil, baste with sauce, and grill to desired degree of crispness.

1 (2 ½-pound) racks baby back ribs

2 tablespoons Sweet-and-Spicy BBQ Blend (page 227)

½ cup prepared barbecue sauce

PREP AT HOME:

Remove membrane from back of each rack of ribs. Cut each in half to make 4 groups of (3 to 4) ribs.

Sprinkle BBQ rub evenly over both sides of ribs. Wrap each rack in 2 layers of heavy-duty aluminum foil.

AT CAMPSITE:

Prepare a charcoal or gas grill for medium heat.

Grill prepared ribs (coated with BBQ rub and wrapped in foil) for 1 hour, turning occasionally.

Remove foil packs from grill, and carefully remove ribs from foil. Baste ribs with half of sauce. Grill, bone side down, 10 minutes, basting occasionally, until outside is crisp and lightly charred. Serve with remaining sauce.

Tip: To remove the membrane from the back of ribs, cut a small piece loose with a sharp paring knife. Then grab the membrane with a piece of folded paper towel and pull it off.

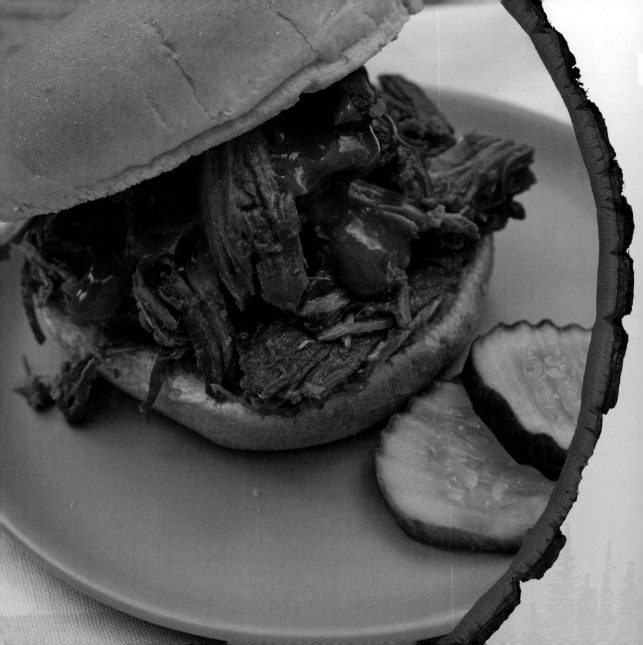

4 ½ pounds boneless pork loin

Salt and pepper

1 tablespoon vegetable oil

2 small onions, chopped

Smoky Molasses BBQ Sauce (page 245)

PREP AT HOME:

Trim excess fat from pork loin and cut in half crosswise (to fit into slow cooker). Sprinkle pork with salt and pepper to taste. Heat oil in a large skillet over medium-high heat. Sear pork pieces on all sides.

Place chopped onions in bottom of a 6-quart (large oval) slow cooker. Place pork pieces on top of onions. Pour 1 cup sauce over pork.

Cover and cook pork 6 hours on High or 8 to 10 hours on Low. Shred pork in the cooker, letting liquid moisten all pieces. Serve from cooker with tongs or a slotted spoon. Drain off excess liquid before storing. Refrigerate in an airtight container 1 week or freeze up to 3 months.

AT CAMPSITE:

Reheat prepared Slow-Cooker BBQ Pork Loin in a skillet or saucepan, if desired. Serve on buns with pickles and additional sauce, if desired.

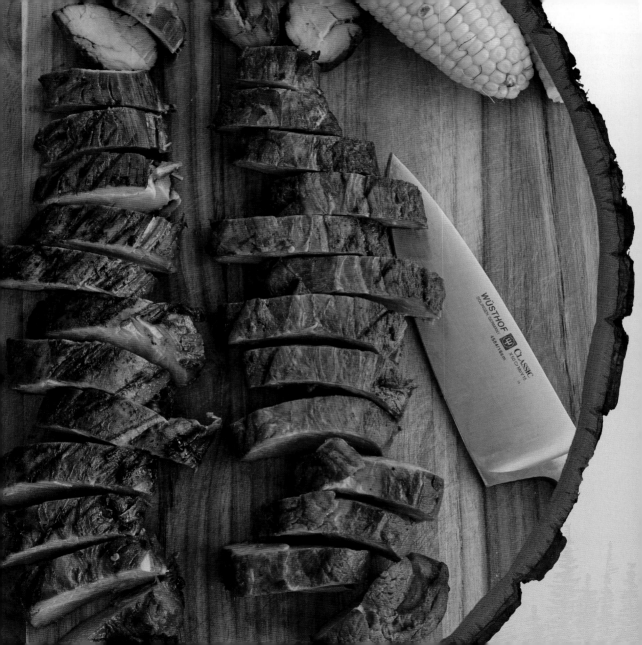

1 (1 ½ to 1 ¾-pound) pork tenderloin

3 tablespoons mild, unsulfured molasses

3 tablespoons apple cider or rice vinegar

2 tablespoons soy sauce

1 tablespoon Dijon mustard

¼ to ½ teaspoon crushed red pepper flakes

PREP AT HOME:

Whisk together molasses, vinegar, soy sauce, mustard, and red pepper flakes in a large plastic storage bag.

Trim tenderloin of excess fat and silver skin. Place in storage bag with marinade; seal, and turn so tenderloin is covered in marinade. Marinate up to 24 hours.

AT CAMPSITE:

Prepare a charcoal or gas grill for medium heat.

Remove pork from marinade (molasses, vinegar, soy sauce, mustard, and pepper flakes), discarding marinade.

Place pork on greased grill rack, and cover with grill lid or sheet of aluminum foil. Grill for 12 to 15 minutes, turning occasionally, until pork reaches an internal temperature of 140°. Remove from grill and let rest 10 minutes before slicing.

Tip: Pork chops less than 1 inch thick can be grilled over direct heat for 3 to 5 minutes. Boneless pork chops will cook quickly, so don't walk away from the grill.

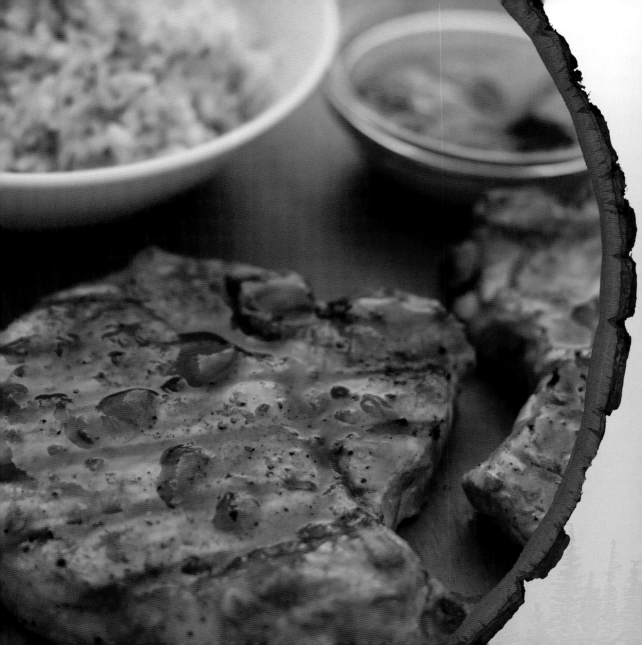

PEACH-GLAZE GRILLED PORK CHOPS

FOR MOIST and juicy pork chops, follow new guidelines from the National Pork Board. Cook pork chops, tenderloin, and roasts to an internal temperature of 145° (medium rare) to 160° (medium), then rest for 3 minutes. Remember to cook chopped or ground pork, like all ground meat, to 160°.

2 (10-ounce, 1-inch-thick) bone-in pork chops

Salt and pepper

¼ cup peach or apricot preserves

1 tablespoon dark brown sugar

1 teaspoon Dijon mustard

½ to 1 teaspoon chili-garlic paste or sriracha sauce

PREP AT HOME:

Stir together peach preserves, brown sugar, mustard, and chili-garlic paste; place glaze mixture in an airtight container in the refrigerator.

AT CAMPSITE:

Prepare a charcoal or gas grill for indirect heat (see page 9).

Sprinkle pork chops with salt and pepper to taste. Grill over high heat 2 to 3 minutes per side. Move to cooler part of grill. Brush with half of glaze mixture (peach preserves, brown sugar, mustard, and chili-garlic paste), and grill 5 to 8 minutes or until internal temperature reaches 145°. Rest 3 to 5 minutes before serving.

Tip: Pork chops less than 1 inch thick can be grilled over direct heat for 3 to 5 minutes. Boneless pork chops will cook quickly, so don't walk away from the grill.

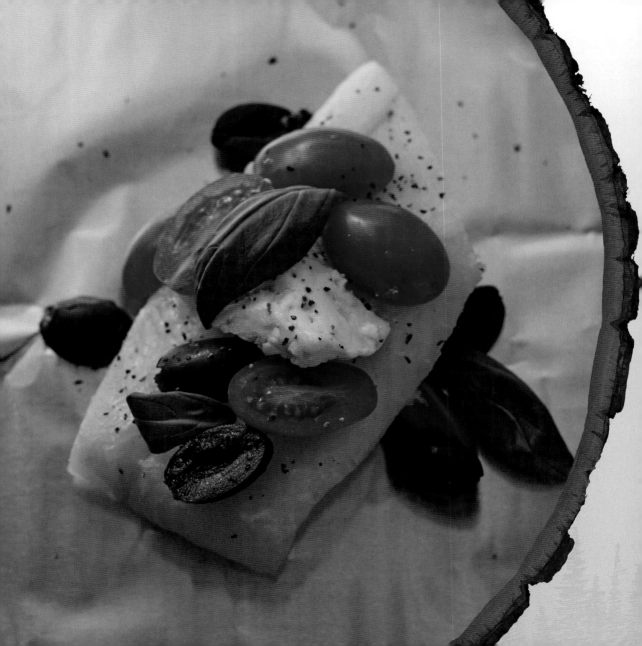

THIS EASY RECIPE is a great first-night choice because it's ready to go, and fish should be eaten within 1 or 2 days. If you are catching your fish at camp, this is still a quick-to-assemble meal. Fish and prep in the morning, and then store the packets in your cooler. Frozen fish works, too, but it tends to water out, so keep the ingredients separate; assemble right before grilling.

4 (6-ounce) boneless, skinless fish fillets

12 cherry or grape tomatoes, halved

12 pitted kalamata olives, halved

4 tablespoons Lemon-Garlic Butter (page 237) or butter

4 to 12 fresh basil leaves

Coarse-ground black pepper

PREP AT HOME:

Prepare Lemon-Garlic Butter. Place in a plastic storage bag in the freezer or refrigerator.

Cut 4 (12- x 15-inch) pieces of heavy-duty aluminum foil. Place 1 fillet in center of each foil piece.

Top fillets evenly with tomatoes and olives. Top each with 1 tablespoon Lemon-Garlic Butter. Top each with 1 to 3 fresh basil leaves; sprinkle with pepper.

Fold opposite sides of each foil packet together. Fold over edges to seal. Keep in refrigerator or cooler until ready to cook.

AT CAMPSITE:

Prepare a gas or charcoal grill or campfire for medium-high heat.

Grill prepared fish fillets (topped with tomatoes, olives, butter, basil, and pepper and wrapped in foil packets) 5 to 7 minutes on each side or until packets are puffed and insides are sizzling. Carefully open foil and allow steam to escape.

Tip: You can assemble and grill these simple fish dinners at home or at the campsite. If you notice a hole in the foil, you don't have to start over. Just wrap another piece of foil around the packet.

2 individual (or 1 long) cedar or alder planks

1 (10- to 12-ounce) salmon fillet, cut into 2 pieces

2 teaspoons Dijon mustard

1 teaspoon Sweet-and-Spicy BBQ Blend (page 227)

GARNISH: chives, chopped

PREP AT HOME:

Prepare Sweet-and-Spicy BBQ Blend.

Cut salmon into serving-size portions, if desired, to make it easier to store in the cooler.

AT CAMPSITE:

Soak planks in water for at least 30 minutes; drain.

Prepare a charcoal or gas grill. Grill plank 5 minutes or until grill marks appear. Remove from grill.

Place salmon, skin side down, on grilled side of plank. Spread 1 teaspoon mustard evenly over each salmon fillet, and sprinkle each evenly with ½ teaspoon spice rub.

Place planked salmon on grill. Cover or tent with aluminum foil. Grill 15 to 20 minutes or until desired degree of doneness. Sprinkle with chives, if desired.

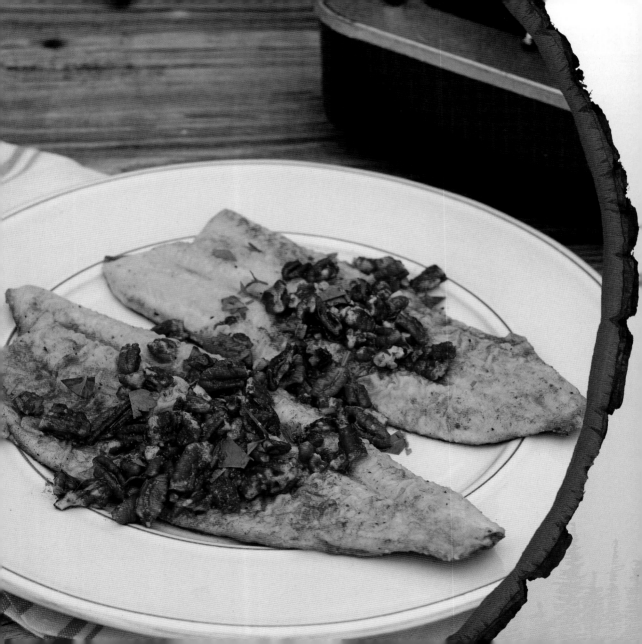

BROWNED BUTTER AND PECAN TROUT

SERVINGS; WPS = 8 OZ.

SMALL, PAN–SIZE trout fillets work best for this recipe. One large fillet can be cut in half crosswise to fit in a skillet. You can also substitute any flat, quick–cooking fish like flounder or catfish.

2 (6-ounce) trout fillets

Salt and pepper

¼ cup all-purpose flour, rice flour, or almond meal

4 tablespoons butter, divided

¼ cup chopped pecans or slivered or sliced almonds

1 tablespoon fresh lemon juice

1 teaspoon Worcestershire sauce

1 tablespoon chopped fresh parsley or 1 teaspoon freeze-dried parsley flakes

PREP AT HOME:

Unwrap fish and place on paper towels between 2 plates in the coldest spot in the refrigerator. To transfer to a cooler, place fish in a plastic storage bag, remove air, and seal. Surround fish with ice, and check to make sure bag remains sealed so fish does not get soaked in icy water. Cook as soon as possible (within 2 days).

AT CAMPSITE:

Sprinkle trout with salt and pepper to taste. Dredge in flour, shaking off excess.

Melt 2 tablespoons butter (or oil) in a large nonstick skillet over medium heat. Add trout, skin side up, and cook 2 minutes. Turn and cook 2 minutes or until done. Transfer to a plate or platter.

Melt remaining 2 tablespoons butter in skillet. Add nuts and cook 1 to 2 minutes or until golden brown. Stir in lemon juice, Worcestershire, and parsley. Pour over fish and serve immediately.

SEAFOOD 195

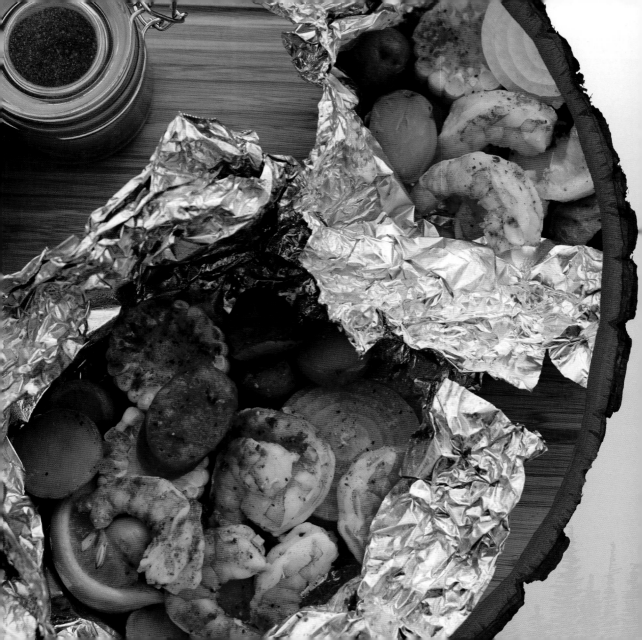

SHRIMP BOIL IN FOIL

1 pound very small red potatoes

1½ pounds large shrimp, peeled and deveined

12 ounces smoked andouille sausage

3 ears fresh corn, shucked

1 onion

1 lemon, cut into 6 wedges

2 tablespoons butter or Lemon-Garlic Butter (page 237)

1 ½ tablespoons seafood seasoning or Cajun Spice Mix (page 231)

French bread

PREP AT HOME:

Cut potatoes in half. If potatoes are larger than the size of a quarter in diameter, microwave them on HIGH for 4 minutes or until tender; cool slightly. If assembling at campsite, quarter potatoes, making sure pieces are evenly sized so they cook at the same time.

Peel and devein shrimp. Cut sausage diagonally into ¼-inch-thick slices. Cut corn into 1-inch pieces. Slice onion. Cut lemon into 6 wedges. Slice butter into 6 teaspoons; set aside.

Cut 6 (18-inch-long) pieces of heavy-duty aluminum foil. Divide potatoes, shrimp, sausage, corn, and onion in center of each piece of foil. Squeeze one lemon wedge over each mixture, and place 1 lemon rind and 1 pat of butter on top of each. Sprinkle evenly with seafood seasoning. Bring opposite ends of foil together, and fold edges over. Fold remaining ends to seal packets. Store in refrigerator 1 day ahead or assemble at campground.

AT CAMPSITE:

Prepare a gas or charcoal grill for medium-high heat, or prepare a wood campfire.

Grill prepared foil packets (filled with potatoes, shrimp, sausage, corn, onion, lemon, butter, and seasonings) 8 minutes on one side. Turn over and cook 5 to 7 minutes or until done. Transfer to plates and carefully open to allow steam to escape. Serve with bread, additional lemon wedges, and additional seafood seasoning, if desired.

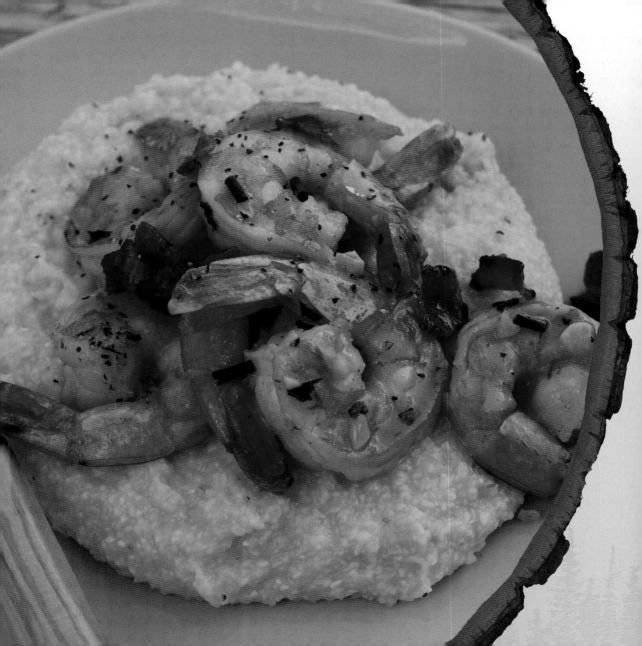

Cheesy Grits (recipe below)

3 slices bacon

1 pound large shrimp

2 to 3 tablespoons Lemon-Garlic Butter (page 237)

PREP AT HOME:

Grate cheese for Cheesy Grits. Cover and refrigerate until ready to use.

Chop bacon, if desired. Peel and devein shrimp, if desired.

Prepare Lemon-Garlic Butter. Refrigerate or freeze until ready to use.

AT CAMPSITE:

Prepare a gas or charcoal grill.

Prepare Cheesy Grits; cover and keep warm.

Cook bacon in a heavy skillet over medium-high heat. Remove bacon with a slotted spoon and set aside.

Add shrimp to skillet. Cook, stirring frequently, 1 minute. Add Lemon-Garlic Butter; cook, stirring frequently, 5 minutes or until shrimp are done. Stir in bacon.

To serve, spoon shrimp onto hot cooked grits.

Cheesy Grits

Combine 2 vegetable or chicken boullion cubes and 2 cups hot water. Bring to a boil over medium-high heat, stirring until bouillon dissolves. Stir in ¾ cup quick-cooking grits. Cook, stirring frequently, 5 minutes or until thickened. Stir in salt and pepper to taste and ½ cup (2 ounces) Parmesan or Cheddar cheese. Makes about 3 cups.

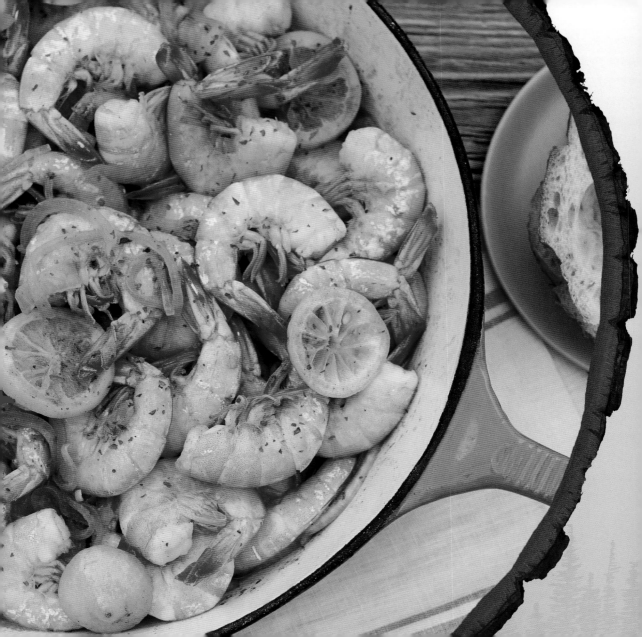

FOR THIS RECIPE, unpeeled shrimp is usually better because the shells impart some flavor. If you object to the mess of peeling just before eating, you can peel and devein before cooking.

½ cup (1 stick) butter

3 tablespoons Worcestershire sauce

2 lemons, thickly sliced

1 sweet onion, halved and sliced

2 garlic cloves, minced

1 tablespoon seafood or Cajun Spice Mix (page 231)

2 pounds unpeeled large shrimp

½ baguette or 8 thick slices French bread

PREP AT HOME:

Portion ingredients; store in airtight containers.

Peel and devein shrimp, if desired.

AT CAMPSITE:

Prepare a gas or charcoal grill, or assemble a camp cookstove.

Melt butter in a roasting pan or large skillet over medium-high heat. Stir in Worcestershire, lemons, onion, garlic, and seasoning. Cook, stirring occasionally, for 3 minutes or until well blended.

Reduce heat or move pan to cooler side of grill. Add shrimp; cook, turning with tongs, 5 minutes or until pink. Remove from heat and let stand 5 minutes. Serve with sliced French bread.

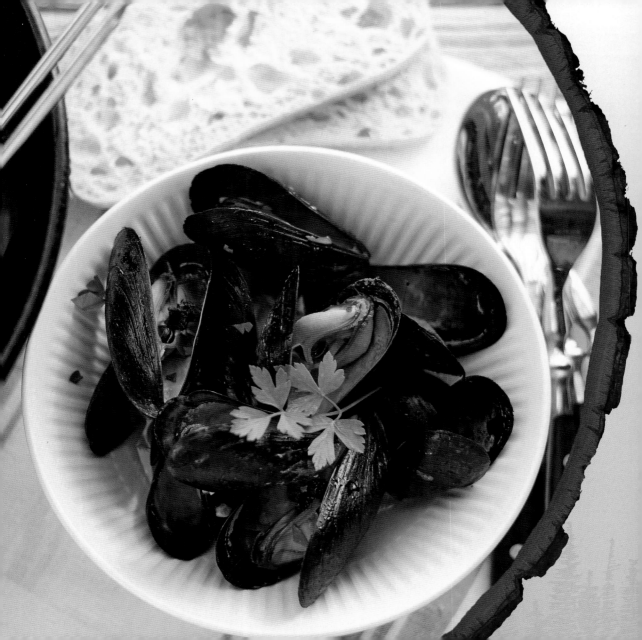

FOR A MORE intense smoky flavor, use hardwood charcoal or add some smoking chips to the grill. Serve the seasoned pan juices with bread for soaking up the rich flavor. Foraging for wild mussels? Search close to the waterline during low tide. Look for young mussels, about 2 to 3 inches long, with dark, shiny, black shells and sharp, pointed edges. Just before cooking, scrub well and pull off beards toward the hinges. Above all, only forage for mussels in clean, unpolluted water.

2 pounds mussels

½ cup dry white wine or Prosecco

4 tablespoons butter

3 garlic cloves, minced

⅛ to ¼ teaspoon dried chili flakes

Parsley to taste

Grilled sliced bread or grilled rolls

PREP AT HOME:

Store mussels in an open container in the refrigerator or in a separate container over a pan of ice, with a bag of ice on top. Do not submerge in ice; as the ice melts, the mussels on the bottom will "drown."

AT CAMPSITE:

Prepare a charcoal or gas grill.

Scrub mussels under running water, removing beards (farmed mussels won't have beards). Discard any that remain open or have broken shells.

Combine wine, butter, garlic, and chili flakes in a small pot or skillet with lid. Place over heat and cook, stirring occasionally, 2 to 3 minutes or until butter melts. (Don't let garlic burn!)

Add mussels, tossing gently to coat. Cover with lid or aluminum foil. Cook 10 to 12 minutes, shaking pan occasionally to stir. Most, if not all, mussels should be open. If many are not, cover and grill 2 to 5 more minutes. Discard any mussels that remain unopened. Sprinkle with parsley and serve with grilled bread.

Desserts & Beverages

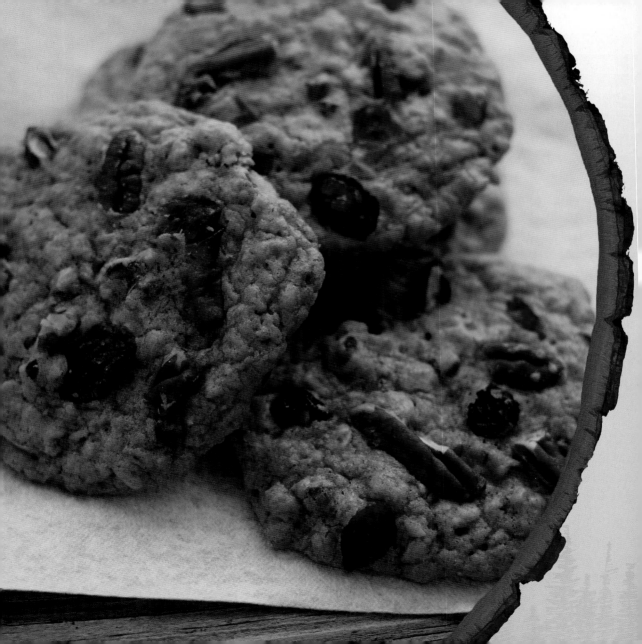

CHOCOLATE CHIP TRAIL COOKIES

4 1/2 DOZEN; WPS = 1.25 OZ. (PER BAKED COOKIE)

1 cup butter, softened

1 cup firmly packed light brown sugar

¾ cup sugar

2 large eggs

2 teaspoons vanilla extract

2 cups all-purpose flour

2 cups old-fashioned or quick oats

1 teaspoon baking soda

½ teaspoon salt

½ (12-ounce) bag dark or semisweet chocolate chips

1 cup sweetened dried cranberries or remaining bag of chocolate chips

½ cup chopped pecans (optional)

PREP AT HOME:

Preheat oven to 350°. Line 3 baking sheets with parchment paper or nonstick foil.

Beat butter and sugars at medium speed with an electric mixer until fluffy. Beat in eggs and vanilla.

Stir together flour, oats, soda, and salt in a large bowl. Stir flour mixture into butter mixture, blending well. Stir in chocolate chips, cranberries, and, if desired, pecans.

Drop by heaping tablespoons onto prepared baking sheets. Bake 10 to 12 minutes or until light golden brown. Cool 1 minute on pans. Transfer to wire racks to cool.

S'MORES SWEET DARK FUDGE

9 large graham crackers (1 sleeve)

3 cups mini marshmallows, divided

1 (14-ounce) can sweetened condensed milk

2 tablespoons butter

12 ounces chopped sweet dark chocolate or semisweet morsels

PREP AT HOME:

Line an 8-inch square baking pan with nonstick or greased foil. Place graham crackers in a plastic bag and crush to fine crumbs. Sprinkle half in bottom of pan, saving larger pieces for topping.

Combine 1 ½ cups marshmallows, condensed milk, and butter in a small pan. Cook over low-medium heat, stirring constantly, until blended. Remove from heat, and add chocolate. Stir constantly, until chocolate melts and mixture is well blended.

Pour mixture into prepared pan. Top with remaining graham cracker crumbs and marshmallows. Cool to room temperature; then wrap and place in cooler until chilled and firm. Cut into squares, using a hot knife for cleanest cuts.

THIS LIGHTER OPTION for cheesecake is naturally sweet with honey and berries.

¾ cup crushed Nut-and-Honey Granola (page 19) or purchased granola

⅓ cup crushed graham crackers (about 2 long crackers)

2 tablespoons melted butter

1 (8-ounce) package reduced-fat cream cheese, softened

1 cup plain Greek yogurt

2 tablespoons honey

2 teaspoons vanilla extract

12 strawberries, sliced

⅓ cup fresh or frozen blueberries

PREP AT HOME:

Combine granola, crackers, and butter in a bowl, stirring until combined. Spoon evenly into 4 (8- to 12-ounce) jars.

Stir together cream cheese, yogurt, honey, and vanilla; spoon evenly over granola crust. Top evenly with berries. Seal or cover jar. Chill for several hours or overnight.

CHOCOLATE burns easily, so use a thick–bottomed pan. You can make this on a grill on very low heat, or cook it over dying embers.

1 cup heavy whipping cream

2 tablespoons light corn syrup

8 ounces sweet dark or semisweet chocolate, chopped

1 teaspoon vanilla extract

DIPPERS: sliced strawberries, bananas, and apples; marshmallows; cubed pound cake; graham crackers

PREP AT HOME:

Note: You can make the fondue at home and reheat over low heat at the campsite, if desired.

Chop chocolate, if desired; store in an airtight container.

Wash berries and apples, if using.

AT CAMPSITE:

Set up a camp cookstove. Recipe can also be prepared on a charcoal or gas grill.

Heat cream and corn syrup in a small, heavy-bottomed saucepan over medium or medium-low heat. Stir in chocolate. Cook, stirring constantly, until chocolate is smooth and well blended. Stir in vanilla extract.

Skewer fruit and other sweets, and dip into hot chocolate.

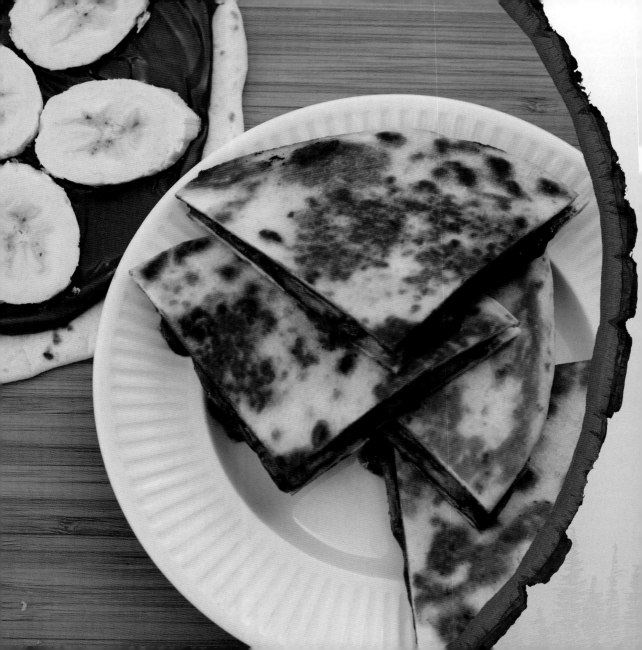

TRY THIS super–easy, oh–so–tasty treat for breakfast too. Eat it over a small plate or napkin because it will drip and get messy. But the mess is worth it!

4 (6-inch) flour tortillas

¼ cup chocolate-hazelnut spread

1 small banana

Butter

AT CAMPSITE:

Assemble a camp cookstove or prepare a charcoal or gas grill for medium heat.

Spread one side of each tortilla evenly with chocolate-hazelnut spread. Slice banana and distribute evenly on 2 of the tortillas. Top with other 2 tortillas, pressing lightly.

Melt a small pat of butter in the bottom of a large nonstick skillet over medium-high heat. Add 1 tortilla; cook 1 minute on each side or until golden brown. Repeat with additional butter and remaining tortilla. Cool slightly and cut into wedges.

Variations: Try sliced strawberries or peaches instead of bananas. Or swap peanut butter for the chocolate spread and drizzle with a little honey. Sprinkle a bit of granola inside for crunch.

DRIED BERRY AND GINGER COBBLER

½ cup dried mixed fruit, such as cranberries, blueberries, cherries, and raisins

1 heaping tablespoon chopped crystallized ginger

5 tablespoons sugar, divided

½ teaspoon ground cinnamon

1 tablespoon butter

½ cup Basic Baking Mix (page 239)

PREP AT HOME:

Combine dried fruit, ginger, 3 tablespoons sugar, cinnamon, and butter.

Prepare baking mix. Combine baking mix and 2 tablespoons sugar; store in an airtight container.

AT CAMPSITE:

Assemble a camp cookstove.

Combine dried fruit, ginger, sugar, cinnamon, butter, and 1 cup water in a small saucepan. Simmer until butter melts and sugar dissolves.

Combine baking mix and 2 tablespoons water, stirring to form a soft dough. Dollop batter over fruit mixture. Cover and simmer 10 to 12 minutes or until dough is cooked.

MINI GRILLED BLACKBERRY COBBLER

I ALWAYS make sure I have extra Basic Baking Mix in my supplies, in case I run across a bounty of fresh berries. This recipe is very forgiving if pickings are slim or the berries don't make it back to the campsite—you end up with a more cake-like dessert. The nuttier texture of whole wheat pairs well with the berries, but use plain if you prefer.

2 cups fresh or 2 (6-ounce) containers fresh blackberries or raspberries

½ plus 2 tablespoons sugar, divided

3 tablespoons butter

¾ cup Whole Wheat or Basic Baking Mix (page 239)

⅔ cup milk

PREP AT HOME:

Prepare baking mix and combine with ½ cup sugar; label and store in an airtight container.

AT CAMPSITE:

Prepare a charcoal fire or a gas grill with lid for indirect heat.

Wash berries; drain but do not pat dry (the moisture will allow the sugar to stick to the fruit). Combine berries and 2 tablespoons sugar in a bowl or plastic bag; set aside.

Melt butter in an 8-inch cast-iron skillet. Combine baking mix with ½ cup sugar and milk in a bowl. Pour batter into skillet over melted butter, stirring gently to combine. Sprinkle fruit evenly on top.

Grill over indirect heat, covered with grill lid, 40 minutes or until batter has risen and center is done. Let stand 5 minutes. Serve warm or chilled.

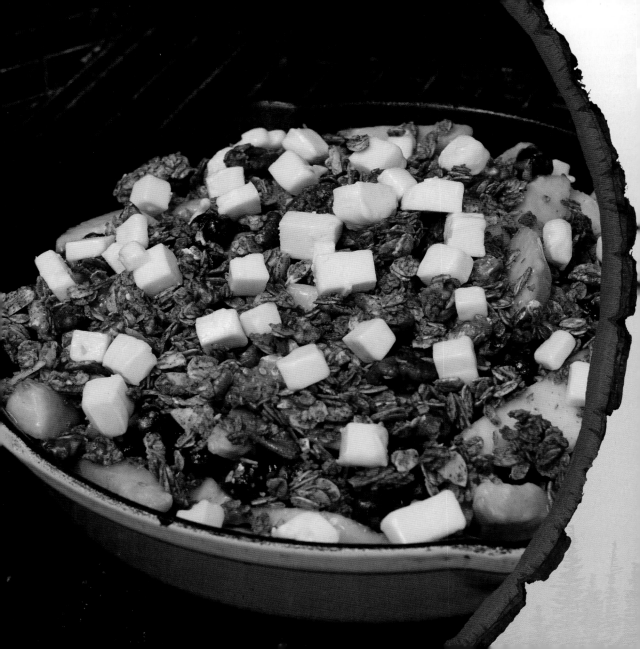

3 cups fresh blueberries

4 large or 5 medium peaches, peeled and sliced

½ cup sugar

⅓ cup all-purpose flour

1 cup Nut-and-Honey Granola (page 19) or purchased granola cereal

4 tablespoons butter, cut into pieces

Vanilla ice cream (optional)

PREP AT HOME:

Prepare granola, if necessary.

AT CAMPSITE:

Prepare gas or charcoal grill for indirect heat.

Combine berries, peaches, sugar, and flour in a large bowl. Spoon into a well-greased 12-inch cast-iron skillet.

Sprinkle granola over berry mixture. Dot with butter. Place on unlit or cooler side of grill. Cover with grill lid; grill 20 to 30 minutes or until hot and bubbly. Rotate skillet occasionally so all sides heat evenly. Serve warm with ice cream, if desired.

Dutch-Oven Directions: Spoon berries into a well-greased 10-quart Dutch oven. Cover with lid. Place over 10 to 12 briquettes. Place 14 to 16 briquettes on lid. Bake 20 to 30 minutes or until mixture is hot and bubbly. Carefully rotate oven and lid once or twice for even cooking.

CAMPFIRE WASSAIL FOR A CROWD

HANGING A POT of simmering wassail over an open fire is a cheerful way to spend a chilly evening with friends at camp or even in the backyard. Use an enamel pot or a very well-seasoned cast-iron oven (not a new one) to avoid stripping off the light seasoning and creating an off flavor.

½ cup firmly packed brown sugar

3 (3-inch) cinnamon sticks or ½ teaspoon ground cinnamon

1 teaspoon ground cloves

½ teaspoon ground nutmeg

1 (12-ounce) can frozen apple juice concentrate

1 (6-ounce) can frozen lemonade, thawed

1 (6-ounce) can frozen orange juice concentrate, thawed

1 (750 ml) bottle white wine

GARNISHES: cinnamon sticks, apple or orange slices

PREP AT HOME:

Combine brown sugar, cinnamon, cloves, and nutmeg; store in an airtight container until ready to use.

AT CAMPSITE:

Prepare a gas or charcoal fire.

Combine 2 cups water; spice mixture (brown sugar, cinnamon, cloves, and nutmeg); apple juice; and lemonade and orange juice concentrates in a Dutch oven or soup pot. Simmer 15 minutes to blend flavors; stir in wine. Simmer until thoroughly heated, and garnish, if desired.

Make a Mix

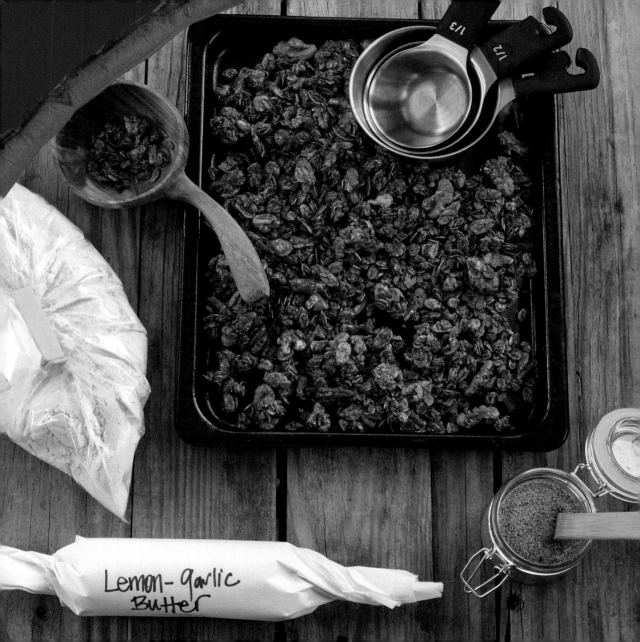

Lemon-garlic Butter

SWEET-AND-SPICY BBQ BLEND

½ cup packed light brown sugar

2 tablespoons kosher salt

2 tablespoons paprika

1 tablespoon chili powder

1 tablespoon garlic powder

1 teaspoon coarse-ground black pepper

1 teaspoon cayenne

PREP AT HOME:

Combine all ingredients; store in an airtight container.

¼ cup chili powder

¼ cup ground cumin

1 tablespoon garlic powder

1 tablespoon kosher salt

1 teaspoon ground coriander

1 teaspoon dried oregano

½ to 1 teaspoon cayenne pepper or crushed red pepper flakes

PREP AT HOME:

Combine all ingredients; store in an airtight container.

¼ cup paprika

2 tablespoons kosher salt

2 tablespoons garlic powder

1 tablespoon onion powder

1 tablespoon dried thyme

1 tablespoon dried oregano

1 teaspoon crushed red pepper flakes

PREP AT HOME:

Combine all ingredients; store in an airtight container.

3 tablespoons paprika

2 tablespoons ground coriander

2 tablespoons ground cumin

1 teaspoon ground turmeric

1 teaspoon ground ginger

1 teaspoon grated lemon rind

1 teaspoon salt

½ teaspoon ground pepper

½ teaspoon ground cinnamon

PREP AT HOME:

Combine all ingredients. Store in an airtight container.

3 tablespoons grated organic lemon rind

2 tablespoons coarse-ground pepper

1 tablespoon kosher salt

PREP AT HOME:

Combine all ingredients; store in an airtight container in the refrigerator.

LEMON-GARLIC BUTTER

1 stick butter, softened

2 garlic cloves, minced

¼ teaspoon lemon zest

½ to 2 tablespoons fresh lemon juice

1 tablespoon chopped fresh parsley

⅛ teaspoon salt

⅛ teaspoon coarse-ground black pepper

PREP AT HOME:

Combine all ingredients. Refrigerate up to 1 month or freeze up to 3 months.

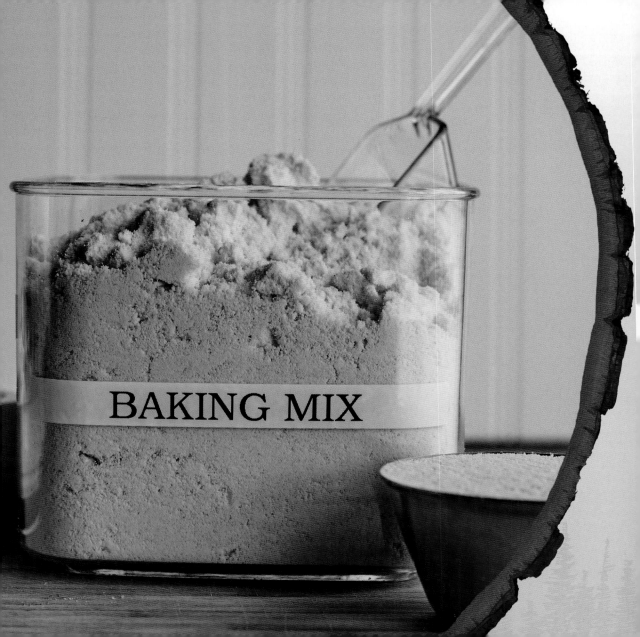

4 cups all-purpose flour

2 tablespoons baking powder

2 tablespoons sugar

1 teaspoon salt

½ cup vegetable shortening

PREP AT HOME:

Combine flour, baking powder, sugar, and salt in a food processor. Add shortening; pulse until mixture resembles coarse meal.

Note: If you don't have a food processor, combine flour, baking powder, sugar, and salt in a large bowl. Add shortening; blend with a pastry blender or fork. Mixture will be slightly lumpy.

Store in an airtight container up to 3 months.

Variations:

Real Butter Baking Mix: Substitute butter for vegetable shortening. Store in an airtight container in the refrigerator up to 1 month.

Whole Wheat Basic Baking Mix: Substitute 2 cups whole wheat flour for 2 cups of the all-purpose flour (for a total of 4 cups). Store in an airtight container in the refrigerator up to 3 months. (Mixture can be stored at room temperature, but whole wheat flour spoils faster than regular all-purpose flour at warmer temperatures.)

BASIC MEAT-AND-VEGGIE MARINADE

½ cup fresh lemon juice (2 lemons)

⅔ cup olive oil

4 garlic cloves, minced

3 tablespoons Sweet-and-Spicy BBQ Blend (page 227)

PREP AT HOME:

Combine all ingredients in a jar. Seal and shake well. Store in refrigerator or cooler until ready to use. Make up to 1 week ahead.

⅓ cup soy sauce

¼ cup rice vinegar

¼ cup canola or olive oil

2 tablespoons honey

1 tablespoon toasted or dark sesame oil

1 teaspoon grated fresh ginger

1 garlic clove, minced

½ teaspoon sesame seeds

PREP AT HOME:

Combine all ingredients in a jar. Seal lid and shake vigorously. Store in the refrigerator up to 1 week.

SMOKY MOLASSES BBQ SAUCE

½ cup chicken broth

1 cup ketchup

½ cup Dijon or yellow mustard

¼ cup Worcestershire sauce

2 tablespoon molasses

1 tablespoon apple cider vinegar

2 teaspoons Sweet-and-Spicy BBQ Blend (page 227) or ground cumin

¾ teaspoon cayenne pepper

2 teaspoons liquid smoke

PREP AT HOME:

Combine all ingredients in a bowl, whisking until well blended. Store in a jar or airtight container in the refrigerator up to 3 months.

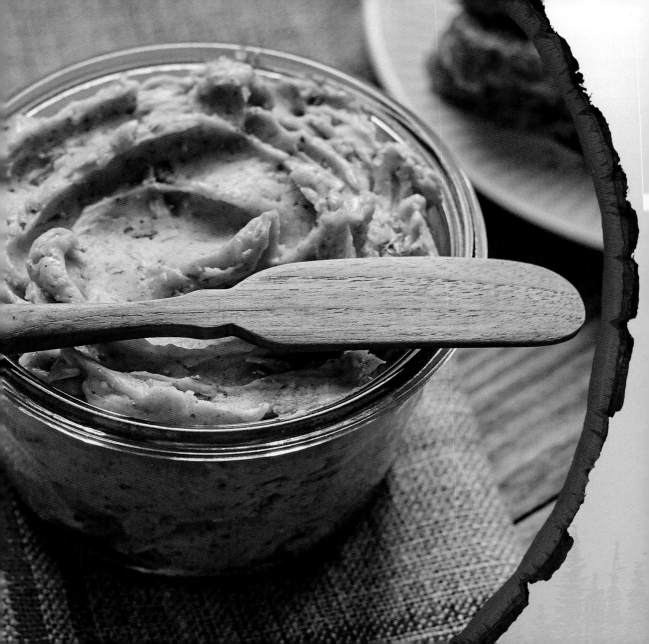

HONEY-PECAN BUTTER

½ cup chopped pecans

1 cup butter, softened

¼ cup local honey

½ teaspoon ground cinnamon (optional)

PREP AT HOME:

Preheat oven to 350°. Spread pecans on a baking sheet, and bake 5 minutes or until very lightly browned and fragrant. Watch carefully the last 2 minutes, as nuts burn easily. Cool completely.

Stir together pecans, butter, honey, and, if desired, cinnamon. Store in an airtight container in the refrigerator up to 2 weeks or freeze 3 months.

AT CAMPSITE:

Let mixture soften 15 to 30 minutes before using.

INDEX

ABOUT THE AUTHOR

Julia Rutland is a Washington, D.C.-area food writer and recipe developer whose work appears regularly in publications and websites such as Weight Watchers books, *Southern Living* magazine, *Coastal Living* magazine, Myfitnesspal.com, and more. She is the coauthor of *Discover Dinnertime* and a contributor to many other cookbooks and websites.

Julia has visited all 50 states and camped with her family in most of them, sleeping in tents, campers, or occasionally just under the stars. Her kitchen gear takes up more space than the tent or other camping supplies because she feels that cooking outside is more fun than hiking. Julia lives in Purcellville, Virginia, with her husband, two daughters, a cat, a couple of dogs, too many chickens, and whatever animals decide to adopt them.

Visit Julia online at www.juliarutland.com